IMAGES
of America

LYNN HAVEN

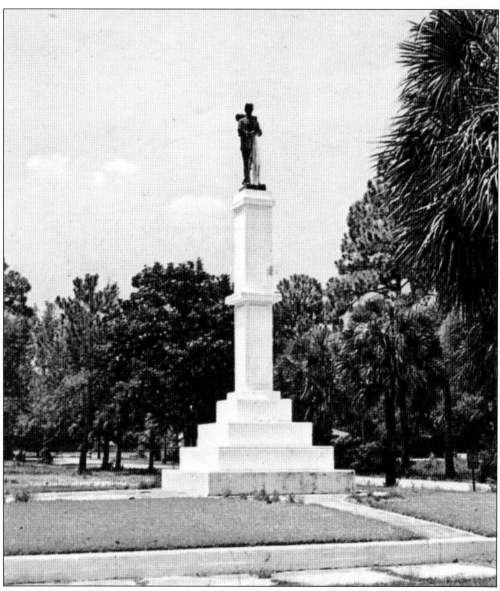

In 1913, Dr. William Krape moved from Freeport, Illinois, to the young city of Lynn Haven, Florida. Settling into the community, he became active in Stanton Post, the local chapter of the Grand Army of the Republic (GAR). The post members responded favorably when he proposed a memorial be built in Lynn Haven to honor those who gave their lives to preserve the Union. Each pledged a portion of his monthly pension check toward the monument's cost, and the women's auxiliary also committed to raise funds. In less than 18 months, the project was begun, completed, and debt free. The monument is situated on a raised, 10-foot-square mound at the corner of Eighth Street and Georgia Avenue. Atop a pedestal 26 feet above the base stands the figure of a Union soldier looking forever toward his home in the North. Dedication ceremonies were held on Lincoln's birthday in 1921. The *Panama City Beacon-Tribune* reported, "There it will stand, silently preaching 100 per cent Americanism to those now living and to generations unborn for many years to come." In 1956, the monument was rededicated to American veterans of all wars. (AC.)

IMAGES
of America
LYNN HAVEN

Glenda A. Walters

Glenda A. Walters

ARCADIA

Published by Arcadia Publishing
Charleston SC, Chicago IL, Portsmouth NH, San Francisco CA

Printed in Great Britain

Library of Congress Catalog Card Number: 2004118338

For all general information contact Arcadia Publishing at:
Telephone 843-853-2070
Fax 843-853-0044
E-mail sales@arcadiapublishing.com
For customer service and orders:
Toll-Free 1-888-313-2665

Visit us on the internet at http://www.arcadiapublishing.com

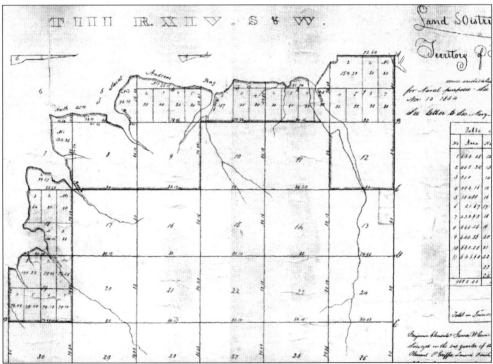

This 1834 map of Land District West, Territory of Florida, indicates the coast line of the northern arm of St Andrews Bay. It is this section that became a colony of Union veterans promoted by William H. Lynn and incorporated in 1913 as Lynn Haven. According to the *Panama City Pilot* on December 15, 1910, "The name Lynnhaven has been given to the town site now being laid out in Section 4 and 9 on North Bay which is about one mile west of Gay."

CONTENTS

ACKNOWLEDGMENTS

I am a Southerner but not a native Floridian. Lynn Haven is my chosen home just as it was for those who came in 1911. In the 1960s, it still offered the beauty, tranquility, and closeness to nature that appealed to those early settlers tired of their struggle with Northern winters. It was still the kind of place where little boys could fish the bays all day, little girls could jump rope or hopscotch into the twilight, and old-timers could sit on a park bench talking of times past. It was a place where you could walk to church, visit the Lloyds at their general store, and get to know your neighbors. It was a good hometown to give your children, and we became part of the community and its story.

Some of my neighbors were surviving settlers, and others were the first generation born in Lynn Haven. I wish I had been blessed with the foresight to listen more closely to their stories and record them. Much was already lost—old pictures, diaries, and journals had been set out with trash as the old houses were torn down over the years. Now I must reconstruct the history of Lynn Haven with the help of another generation.

My thanks go out to all those who were willing to pull out scrapbooks and forgotten boxes of photographs, search the records of social organizations, collect church histories, and allow me to use them. If their efforts recovered only one photograph, we considered it a success to celebrate. I especially want to thank those who had the time to share their experiences and memories with me. They provided immeasurable inspiration and energy to this project, and in so doing, they helped preserve some part of their own story for their descendants. Encouragement was often provided, along with research and technical assistance, by Rebecca Saunders and the staff of the Bay County Public Library.

Finally, I have always enjoyed the support of my own family in whatever project I attempted. Now I am pleased to give my children and grandchildren a chapter in their heritage.

About the cover: The Lynn Haven Women's Club evolved from the Literary Society that banded together in 1911 to overcome the loneliness experienced by women so far from family, old friends, and the lifestyle to which they were accustomed. They met once a week in one another's homes, read passages or poems from their books, and enjoyed piano or vocal performances. Although at their first meeting on November 8, 1911, they had only one book and three magazines contributed, it was their goal to open a library in the new community. By 1915, they had a library with 500 volumes and had outgrown their space in the bank building. The family of Mrs. Elizabeth King McMullen donated a small building to the club in 1922, and thus Lynn Haven got its library. In 1925, the Literary Society joined the General Federation of Women's Clubs and for many years was active both on the state and local level.

INTRODUCTION

Lynn Haven was unique from its beginning. Deep in the piney woods along northwest Florida's Gulf Coast, a Northern developer carved out a town and promoted it as a retirement community for aging Union soldiers. Today the city, chartered in 1913, approaches its centennial. The population has grown to over 14,000, and its boundaries encompass some nine square miles. New homes dot the landscape, and new industries bid workers to come and fill them. Many of Lynn Haven's present-day attractions are the same ones that lured those first settlers: balmy breezes, tropical weather, and a friendly atmosphere. Life along the bay is still as enjoyable as those first settlers found it. Still, the city's rich history, as well as the pioneers who were here in the beginning, should not be forgotten.

In 1910, hundreds of acres of virgin pine and palmetto along St. Andrews Bay were purchased by William Harcourt Lynn, president of a Delaware company chartered as the St. Andrews Bay Development Company. A city of 466 blocks with 16 to 20 lots per block was platted. Avenues running north and south were named for states of the Union. Numbered streets ran east and west. Lots were advertised in the *National Tribune*, a Grand Army of the Republic newspaper, and sold by mail or by agents throughout the country. As an extra inducement, the buyer was also provided a five-acre tract outside the city for his agricultural use.

By 1911, aged men and their often intergenerational families arrived from all over the country and took possession of their property in the new town. Over the next two years, the colony experienced a period of astounding growth. These early 20th-century pioneers and retirees built homes, businesses, and churches. Both men and women worked together to build a community with the refinements that they had enjoyed in their Northern towns. They established social and civic clubs and instituted local government. They provided a school for the children and educational opportunities for all citizens. The women organized a literary club and a welfare league, and they also sponsored the first Chautauqua ever held in Bay County.

One of the first public buildings erected was a meeting hall for the local chapter of the Grand Army of the Republic. Always mindful of their roots, the old veterans raised sufficient funds to erect a monument dedicated to Union soldiers, the only one of its kind below the Mason-Dixon Line. The young city of Lynn Haven received its charter, as did Bay County, in 1913. J.M. Hughey defeated Dr. O.E. Giles for the honor of being the town's first mayor.

Florida's most controversial governor, Sidney J. Catts, paid his first visit to the city to address the opening session of the Chautauqua in 1917. During the next decade, Bob Jones College was built on the outskirts of Lynn Haven by the popular evangelist Bob Jones. Although not within the city boundaries, the school brought attention to the community. To provide additional activities for tourists filling local hotels, a golf course designed by Donald Ross also opened. Prosperity seemed to dwell in the young city through the 1920s, but Florida's economy began its decline even before the Great Depression struck.

Hard times came with the 1930s. Lynn Haven's growth stalled, but most residents stayed. They had not come to this town for riches but for its healthful climate, beautiful scenery, and productive gardens. They intended to live out their years in that environment. Unfortunately, the economy was based on pension checks, and there was nothing to support the town's businesses as many pioneers passed away. With the opening of the International Paper mill, some of the empty homes were moved to Millville, where there was a shortage of housing around the new industry.

However, late in the 1940s, another generation of veterans arrived. All of Florida prospered as veterans of World War II returned and decided to find their place in the sunshine. Lynn Haven became the suburban home to many employed at the U.S. Navy research facility, Tyndall Air Force Base, the International Paper mill, and other Panama City businesses. New homes were built next to those of the pioneer families. Old businesses closed but were replaced by new ones. Mowat Middle School was constructed. Ohio Avenue, now the main thoroughfare, grew to four lanes where things moved faster. The one traffic light became only one of several. Designed to accommodate over 1,500 students, A. Crawford Mosley High School opened in 1972.

Annexation began the spread of Lynn Haven's boundaries in the 1980s, and several new housing developments became part of the city. Once a suburb itself, Lynn Haven now has its own suburbs.

The last decade of the 20th century was one of rapid growth. A new recreation complex complete with baseball and soccer fields, a playground, and a community center was built. The golf course was sold to developers, who redesigned the course to accommodate waterfront homes, and a new clubhouse for members was built in the early 1990s. A new, four-lane Bailey Bridge opened. Churches outgrew their original buildings and constructed new sanctuaries. New churches have joined the old and are filled with new residents. The Lynn Haven Industrial Park was developed and now is home to several environmentally friendly manufacturers and distributors. The Commerce Park was added and also accommodates several plants and distribution centers. Annexation north across the bay continues as high-rise condominiums rise like the smoke of the old lumber mills.

Now, it is time to give this unique colony, home of Union veterans who returned to the sunny South in peacetime, the attention it deserves.

KEY TO PHOTOGRAPH SOURCE ABBREVIATIONS

Bay County Public Library	BCPL	Author's Collection	AC
Lynn Haven Public Library	LHPL	E.W. Greer	EWG
City of Lynn Haven	CLH	Sharon Sheffield	SS
Lynn Haven Garden Club	LHGC	Sarah Hutton	SH
Mowat Family Collection	MFC	Montel Johnson	MJ
Talley Bludworth	TB	Shirley Kilpatrick	SK
Gene Kyser	GK	Marvin McCain	MM
Roberts Family Collection	RFC	Kay Titus Tally	KTT
Susan Atkinson	SA	Kinsaul Family	KF
Libby Tunnell	LT	George Green	GG
Robert L. McKenzie	RLM	Lloyd Stanley	LS
Guy Jencks Jr.	GJ	Bailey Family	BF
Lynn Haven United Methodist Church	LHUMC		

One
THE BEGINNING

I do not believe there ever was another town the size of Lynn Haven that had so many interesting old people as were here that first year.

—Mrs. D.J. Bailey

Even before the exact location was announced, veterans began to move into the area in search of the proposed colony. The *Panama City Pilot* monitored every newcomer and every business transaction of the St. Andrews Bay Development Company. William Lynn bought property in different locations around what was Washington County at that time, but the city fathers of other municipalities were more rivals than partners. Thus, Lynn determined to develop an independent colony.

The *National Tribune* was filled with stories of success in other veterans' communities like St. Cloud, Florida, and Fitzgerald, Georgia. Veterans in those colonies had found the key to good health and long life according to their testimonials. Lynn Haven could well be the last chance at such an opportunity, so from far and wide, the old soldiers sent their money and dreamed of life in the sunshine. Many braved the perils of travels and the trauma of relocation to arrive with little except big plans. An adventure began!

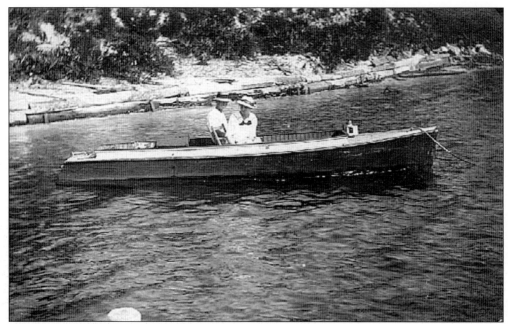

Perhaps this waterfront scene reveals the attraction that lured many settlers from their cold and wintry climates to the shores of North Bay. This tranquil water scene is typical of the idyllic environment promised to those who settled in the new town. (BCPL.)

The greatest lure may have been the promise of abundant fresh fruit and vegetables. Many who came were fascinated by the exotic plants they were able to grow. The newspaper gave weekly accounts of gardeners' accomplishments. (BCPL.)

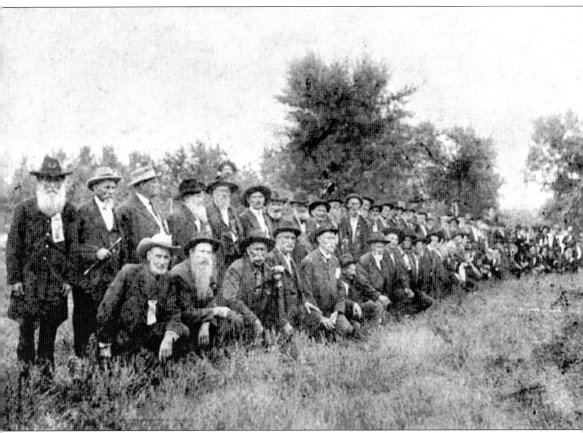

Whatever the reason for coming, the old veterans and their families began to flock to the area even before the exact location of the settlement was announced. The *Panama City Pilot* reported that it had received numerous inquiries into the location of the proposed development and as to the number of veterans moving into the area. As a result of these questions, the newspaper began compiling and publishing a list of newcomers as early as December 29, 1910. The list included family members who accompanied the veterans as well as the names of the military units in which they served and their hometowns. The majority of the men represented Ohio, Indiana, Pennsylvania, and New York. The list continued to be updated as a weekly feature of the newspaper until February of 1911. This old photograph shows members of the Stanton Post No. 2, Department of Florida, the local chapter of the veterans' association of the Grand Army of the Republic. This group was chartered in 1911, and Wilbur Fisher Ward, a veteran from Maine, was named its first quartermaster. (BCPL.)

Neither promoters nor veterans were the first to select the northern arm of St. Andrews Bay as a promising site. Andrew Jackson Gay moved to a bluff overlooking North Bay from Blakely, Georgia, in 1884. The Gay home place became officially known as Gay, Florida, when the government established a post office there in 1895. Mary E. Gay was the postmistress. Mr. and Mrs. Gay had three children: Leslie, Roswell, and Alla Vesta. (RLM.)

This is the home of Leslie C. Gay (the son of A.J. Gay), located along the North Bay waterfront, as it appeared when William Lynn visited the area. The Gays strongly supported the addition of a veterans' settlement to the area. By January 1911, Lynn purchased nearly 18,000 acres from A.J. Gay and his wife. That land, in conjunction with additional tracts purchased from other companies and individuals, became part of the proposed GAR community. (RLM.)

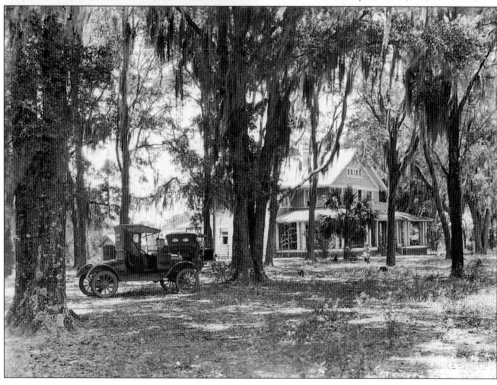

Here, members of the Gay family can be seen enjoying an afternoon along the picturesque bay front lane. This bluff gave a panoramic view of the bay and the opposing shoreline. (RLM.)

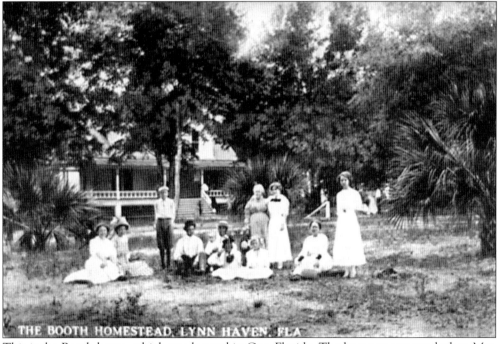

This is the Booth home, which was located in Gay, Florida. The home was vacated when Mrs. Belle Booth was widowed and moved into Panama City. W.H. Lynn rented the home and used it as his local base of operation during the early stages of Lynn Haven's development. (BCPL.)

The Gay cemetery was once the family burial plot, but today the seven marked headstones are nestled beneath the oaks along the Number 6 fairway of the Panama Country Club. The little plot is cordoned off and respected by those playing. (AC.)

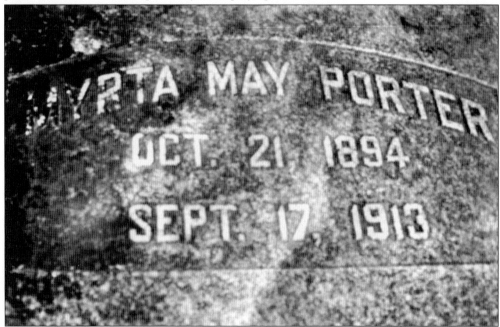

Here is an example of the old headstones still marking graves in the Gay Cemetery plot. It reads, "Myrta May Porter Oct. 21, 1894–Sept. 17, 1913." (AC.)

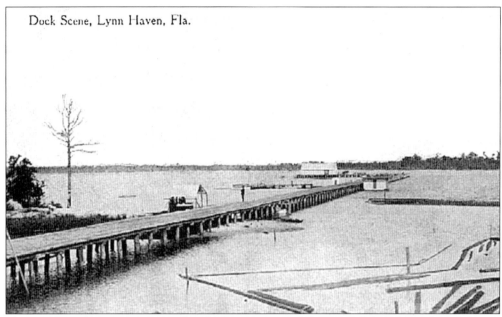

Dock Scene, Lynn Haven, Fla.

The contract for construction of a dock was awarded to H.W. Johnson, and work began immediately since supplies and settlers arrived by boat. Located at the end of Pennsylvania Avenue, this wooden wharf extended 1,850 feet out into the bay. Its 25-foot width permitted wagons and teams to be driven down the dock to unload cargo from a boat. On the west end of the pier was the location of the dock house where freight was handled. (BCPL.)

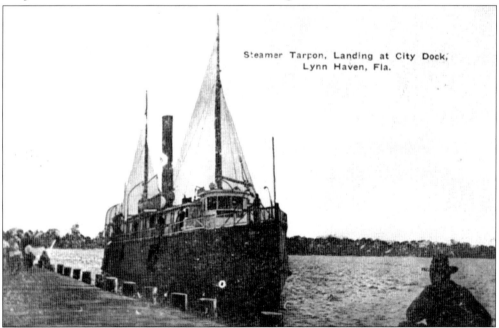

Steamer Tarpon, Landing at City Dock,
Lynn Haven, Fla.

Supplies were first brought by small vessels. The launch *Don* made two round trips daily between Panama City, St. Andrews, and Lynn Haven. The *Petrel* made one round trip between Lynn Haven and Southport each morning. In 1912, the steam-powered *Tarpon* began making regular stops each Friday morning. (BCPL.)

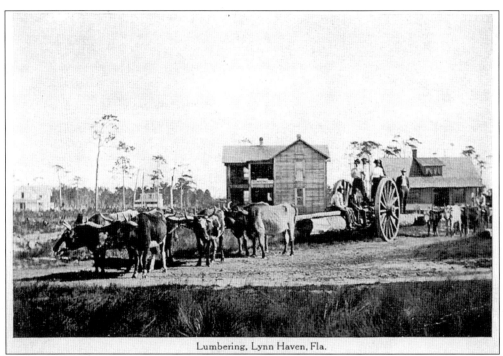

Lumbering, Lynn Haven, Fla.

Lumber for construction in the new town was first brought over from Mr. Gay's mill at Grassy Point. The demand was so high that the Southport Lumber Company increased production and opened a retail lumberyard at Lynn Haven under the direction of Mr. Leslie Porter. Later, a sawmill was open by Mr. C.C. Richards on Ohio Avenue between 10th and 11th Streets. (RFC.)

The New York Avenue home of Emery and Mollie Truesdell became the social center of the community and exemplified the culture of its residents. Emery, a veteran of the 8th New York Cavalry, and his wife found that retirement was not their style. They became the local sales agents for the St. Andrews Bay Development Company and sold over 4,000 lots for the company. Later, they were partners in the real estate agency of Boostrum and Truesdell. (BCPL.)

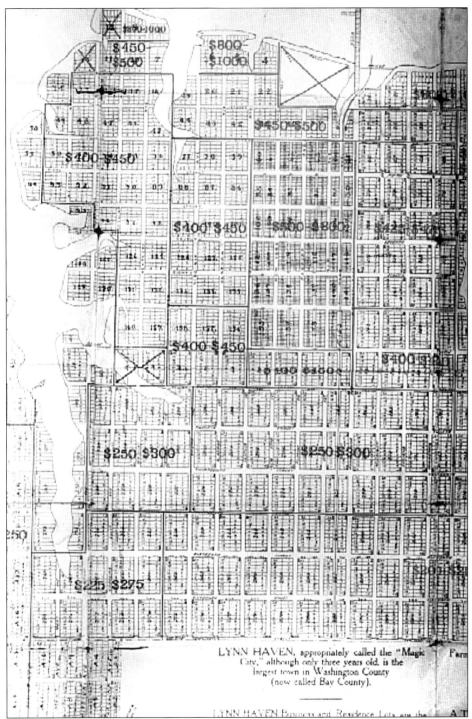

LYNN HAVEN, appropriately called the "Magic City," although only three years old, is the largest town in Washington County (now called Bay County).

LYNN HAVEN Business and Residence Lots are the

Lots, measuring 50-by-150 feet, were sold site unseen by a lottery system. As an added incentive, buyers received a five-acre tract of land for agricultural purposes outside the city. The development company needed cash in 1913, and this map shows the price and location of lots they were marketing at that time. (RFC.)

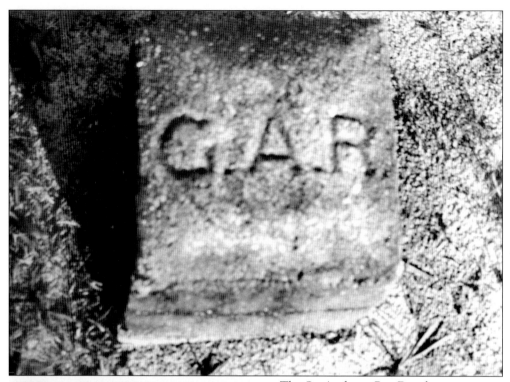

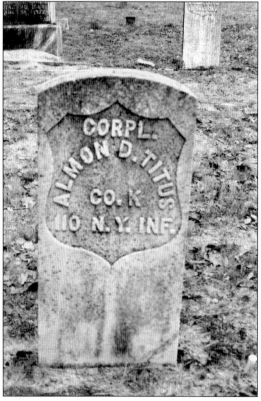

The St. Andrews Bay Development Company provided land for a community cemetery. On September 4, 1911, the Ladies Auxiliary of the GAR dedicated the two-acre tract on the town's southeastern border as Oakland Cemetery. Corner posts marked with GAR, such as this one, indicated the four corners of sections reserved for veterans' burial. As the years passed, the site became known simply as the Lynn Haven Cemetery. (AC.)

Although few of the graves are dated, obituaries indicate that some of the settlers lived amazingly long lives. The space for dates on the stone was forfeited so that military affiliation could be included. (AC.)

Two

REMEMBERING HOME

Those were trying days, attended with many discouraging instances. Had we been asked why we stayed, we could have told. We stayed because the blood of our ancestors—the pioneer and the patriot—was flowing in our veins and hope is the last thing to die in the human heart.

—Mollie Truesdell

They had for the most part enjoyed comfortable surroundings, but they sacrificed that lifestyle to search for good health. The promise of warm sunshine and no winter snow motivated these hardy individuals to come south and carve a home out of untamed land. They may not have anticipated humidity, mud, and mosquitoes or wild hogs lying in the roadway, but once they arrived, most stayed. Mrs. Mollie Truesdell once said that her husband had stuffed his cigar butts in the holes of their walls to keep the wind out that first year. Rather than pine for the refinements they had left behind, the settlers began to duplicate them in their new surroundings. Education, music, and literature were incorporated into the life of the colony from its beginning, and life went on with births, weddings, and death, just as it had in their Northern homes.

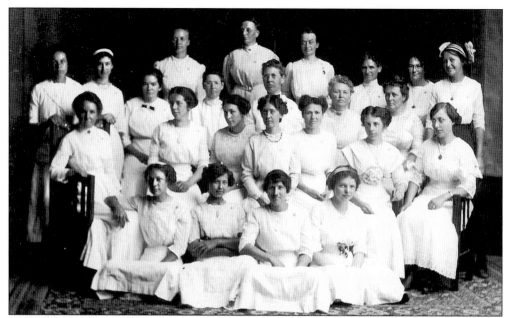

Union Sunday School was the name selected by the assorted Christians who met each week at Temple Grove. There, beneath the oaks at the end of New York Avenue, the settlers held the first religious services. Attendance at these nondenominational services often exceeded 100. Here, the women's Sunday school class, Daughters of the King, pose in their white dresses. (RFC.)

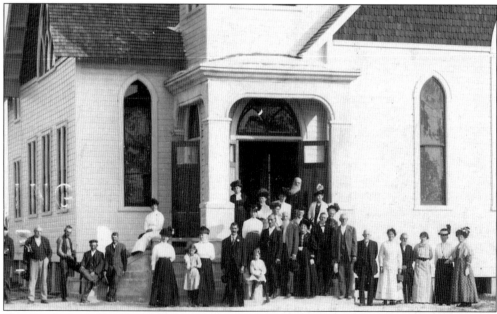

The St. Andrews Bay Development Company promised two lots to any religious group that would build a house of worship. The Methodist Episcopal Church, led by Rev. R.W. Burdeshaw, was organized on June 1, 1911, and became the first to take advantage of that offer. The church formally opened with evening services on November 21, 1912. Members shown here held dedication services in 1917, when the construction note was paid in full. (LHUMC.)

Rev. Louis Grosenbaugh arrived in 1921 and guided the congregation of the Methodist church until 1924. The organizing pastor, Rev. R.W. Burdeshaw, was followed by Rev. W.R.S. Burnett. Rev. William Croman became pastor in 1915. He was active in fund-raising until the church construction debts were paid. A number of supply pastors followed until Reverend Grosenbaugh arrived to serve three years. (LHUMC.)

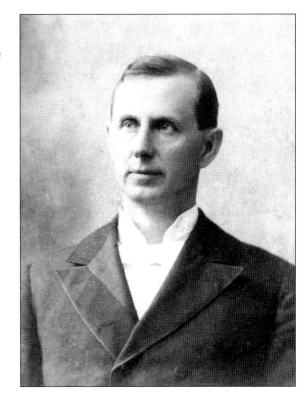

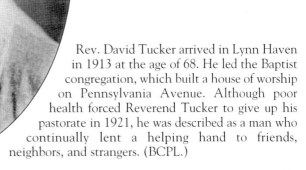

Rev. David Tucker arrived in Lynn Haven in 1913 at the age of 68. He led the Baptist congregation, which built a house of worship on Pennsylvania Avenue. Although poor health forced Reverend Tucker to give up his pastorate in 1921, he was described as a man who continually lent a helping hand to friends, neighbors, and strangers. (BCPL.)

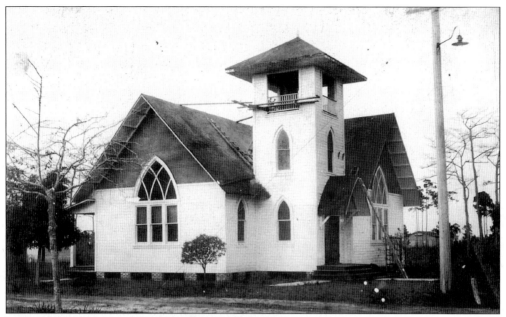

Late in 1912, a group of 31 individuals notified the Florida Presbytery that they were ready to organize a Presbyterian church. An organizational meeting was held in January, and 22 people signed a covenant to form First Presbyterian Church. Ira Miller of Rockport, Indiana, arrived in 1914 to serve as minister. Construction of the sanctuary at the corner of Ninth Street and Georgia Avenue began the following year. The first services were held there in 1916. (MFC.)

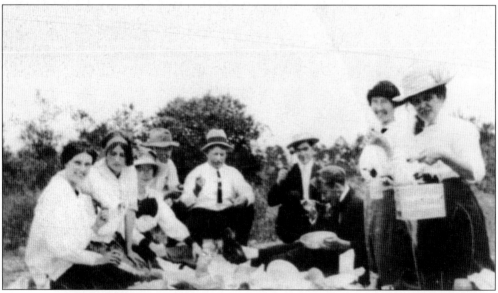

A picnic usually meant an outing for friends and neighbors, both young and old, that would take the entire afternoon. The picnic party usually set out by boat to visit some favorite site outside of town. One such group planned to go up Bear Creek, visit the alligator farm, and then travel to McAllister to spread their lunch of fried chicken, beet pickles, boiled eggs, and berry pie, all home-grown! Included in this happy group are Bertha and Ben Gessel, Jon Gessel, M. Wilkes, and Dr. ? Landis. (BCPL.)

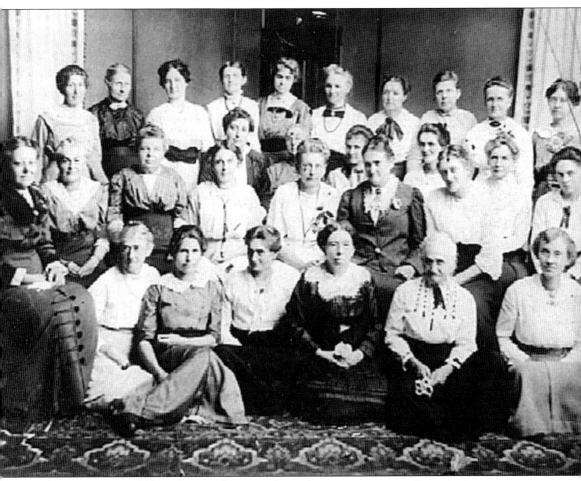

The Women's Welfare League functioned as the primary women's civic improvement organization in Lynn Haven. In 1913, they posed for this group picture. From left to right are (front row) Mrs. L.J. Roberts (president, in chair), Mrs. Ebersole, Mrs. Wagner, Mrs. Beauticulfer, Mrs. Griffith, Mrs. Stevens, and Mrs. Bertha Gessel; (second row) Mrs. Colcord, Mrs. White, Mrs. Pomeroy, Mrs. Bauer, Mrs. Caruthers, Mrs. Mollie Truesdell, and Mrs. Wilbur; (third row) Miss Mary Lynn, unidentified, Mrs. Braten, Mrs. Geneva Jackson, and Miss Mary Bond; (fourth row) Mrs. Jocelyn, Mrs. Mary Burnette, Mrs. Etta Titus, Mrs. Teeter, Mrs. Royce, Mrs. Hanford, Mrs. Miles, Mrs. Beach, Mrs. Johnson, and Mrs. Shives. (BCPL.)

Dressed to participate in the Fourth of July celebration, these children are gathered at Temple Grove. Peaceful Temple Grove was the bay front site of worship and memorial services as well as celebrations. (RFC.)

The Fourth of July was first celebrated in Lynn Haven in 1911. Here can be seen the newly organized band performing on Florida Avenue in that celebration. The band did not need much prompting to perform. They would sometimes participate in wedding processionals from the church to the reception. (BCPL.)

Although Lynn Haven was a primitive settlement, the transplanted Northerners did not intend to do without the cultural activities that they had enjoyed in their former homes. Music was an important part of the community, beginning with the organization of a 32-piece band by H.L. Ball as early as 1911. (BCPL.)

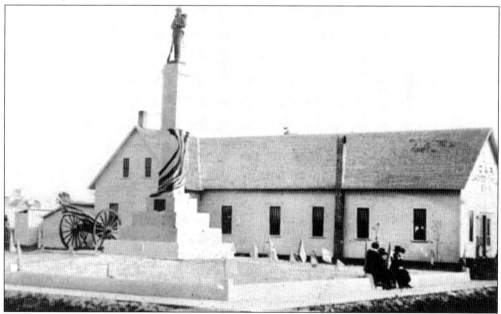

The Grand Army of the Republic veterans' organization was the common bond between the settlers. Not only was the women's auxiliary organized, but a chapter of Sons of the GAR was also formed and became quite active. The GAR Hall was one of the first buildings completed in 1911 and served as a community center as well as a meeting hall. This is how it looked in the early 1920s after the monument was raised. Note the Civil War cannon pictured. (BCPL.)

25

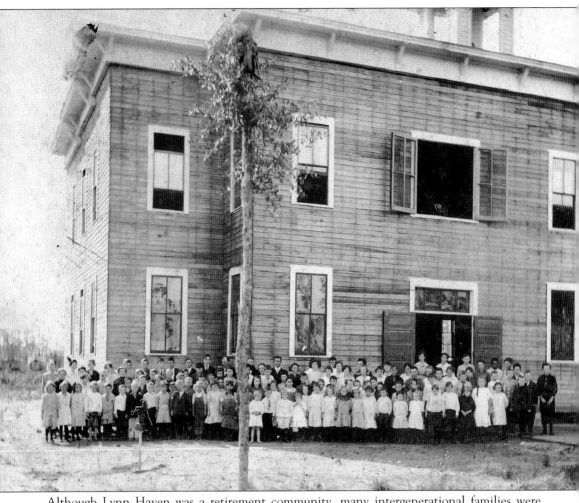

Although Lynn Haven was a retirement community, many intergenerational families were among the settlers. There were a considerable number of children, whose education was of immediate concern. The Committee on Education hired two teachers, equipped classrooms on the second floor of the bank building, and opened school in January 1912. Four faculty members were hired when this two-story school located on Ninth Street was completed in October 1913; they were Professor ? Davis, Miss Manta Bailey, Miss Grace Yutzy, and Mrs. ? Bush. E.I. Matthews was principle. This structure was used until the 1930s when a single-story, frame school building was completed as a WPA project. (LT.)

To raise funds for construction of a school in Lynn Haven, citizens sponsored the first ever Bay County Fair in September 1913. The fairgrounds were located in the schoolyard along Ninth Street between Georgia and Alabama Avenues. Two excursion trains and private transportation brought about 500 visitors from Panama City to join the 2,500 Lynn Haven residents in enjoying the fair. The "Beautiful Babies" contest was the high point of entertainment. Pictured here is the first place winner, Florida Jane Bailey, daughter of D.J. and Cora Bailey. Second place was won by Andrew McKenzie, and third was won by Evelyn Purcell of St. Andrews. (BF.)

27

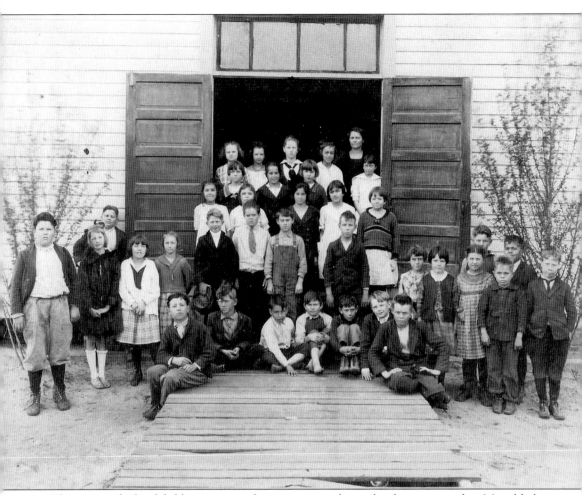

This group of schoolchildren poses at the entrance to their school on picture day. Most likely, it is the entire number of students enrolled. Classes were held for the primary grades, one through three, in one of the two downstairs classrooms, while classes for the fourth through sixth grade were held in the other. Upstairs, the seventh and eighth grades were combined. Ninth grade was not offered. The local newspaper noted that the school had been built in a short time considering the work accomplished and was a source of pride to the community. E.I. Matthews held the position of principal. (LT.)

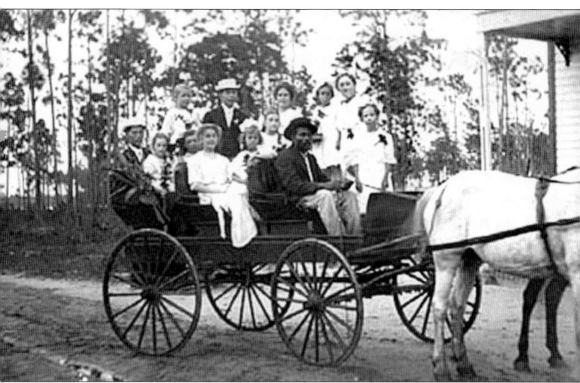

The first church wedding in Lynn Haven took place in the Methodist sanctuary in 1913. Here the wedding party is shown in front of the Bay View Hotel, located at the corner of Fourth Street and Pennsylvania Avenue, where the wedding dinner was held. The bride, Ann Ball, and groom, William Wagner, are surrounded by their wedding party. The maid of honor was Jo Ball and the groomsman was Billy Russell. Seven flower girls—Elizabeth Brandenburg, Ruth Roberts, Rachel Truman, Lucy McCartney, Thora Farr, Mary Shaw, and Violet Hayward—completed the group. In the absence of a minister, Justice of the Peace Mrs. E.P. Truesdell officiated. The earliest wedding in Lynn Haven was held in the Bay View Hotel on January 26, 1912, well before any churches had been built. Mrs. Truesdell also officiated at the quiet ceremony that united widow Mary Crawford with John McLaughlin, a widower of seven years. The couple made a wedding trip to Pensacola aboard the *Tarpon* and then returned to begin life together in their home on Georgia Avenue. (BCPL.)

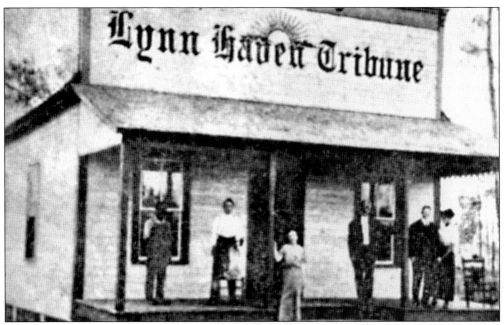

The *Tribune*, Lynn Haven's local newspaper, began publication on June 1, 1911. Each Thursday, the community read a bit of world news, sports, and entertainment, and plenty about their neighbors and the colony's progress. The newspaper office, where daily news was posted on a bulletin board out front, became the hub of the community. (BCPL.)

Friends were probably the most important part of survival in the remote settlement. This group of friends seated on the steps of a home on Illinois Avenue seem to be enjoying a spring day. (AC.)

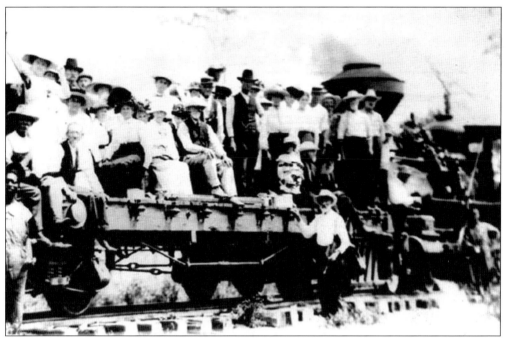

The developers had promised railroad service to link the new town with other cities in all directions. By 1911, right-of-way clearing had begun, but it was July 1, 1913, before the first train traveled down the rails to Panama City. Here are some who made the journey to help celebrate Panama City's first birthday. (BCPL.)

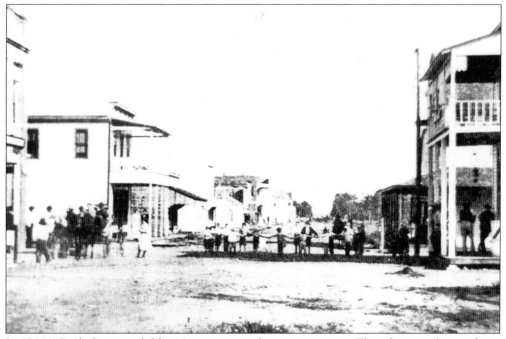

In 1911, Ninth Street and Ohio Avenue was a busy intersection. This photograph must have been made on a Saturday or holiday. The children are circled together in the street playing a game or performing while adults look on. (BCPL.)

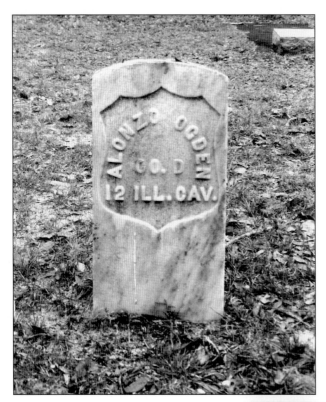

Even as the town began to bustle and build for its future, time ran out for many of the old soldiers. The average age of the veterans who came to Lynn Haven was 65, and accounts written at the time reported it was not unusual for more than one of them to fall dead while conducting business in town. Obituaries usually made mention that death occurred from some condition not associated with the climate. (AC.)

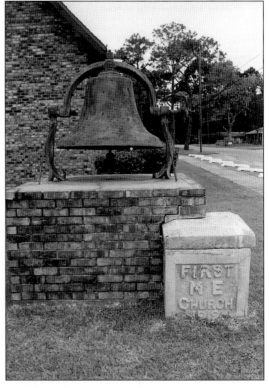

The bell shown here was first hung in the bell tower of the original Methodist church building. In 1954, the bell tower was torn down during a renovation of the church and the bell was placed on a pedestal in front of the building. In 1964, the clapper was replaced, and the bell was rung during homecoming services that year. In this photograph, the bell is shown in front of the second Methodist church building. During the first years of Lynn Haven's settlement, it was rung in recognition of each veteran's death by tolling once for each year of his life. It is said that on some days the bell rang for hours. (LHUMC.)

Three

A City is Born

It is ideal, and there is poetic sentiment and sweet spirit of restful repose in every passing breeze.

—Mrs. Jack Grove, visitor

In a surprisingly short time, the colony went from one with crews cutting palmetto and scrub oaks, mud streets that turned into rivers with the summer rains, and marauding animals to one with neat frame homes, fenced gardens, and busy streets and businesses. The settlers gave an air of refinement in their appearance. A sturdy brick bank, well-dressed businessmen, and gracious hotels were featured in their newspaper. In 1917, the governor of Florida, Sidney J. Catts, visited the city to address the crowds that gathered for the first Chautauqua. Accounts of his visit indicate it was anything but primitive.

Two years after its founding, the citizens of Lynn Haven requested a charter. They were ready to separate from the development company and stand alone. Residents made plans for the future, but unfortunately, many plans failed. The bank failed in 1915. The railroad was not running by 1916 in spite of calls for residents to use it. A deep water port was never built in the county. Even promises of growing vanilla as a profitable crop failed. They were unable to find some business or industry that would build a base for the city's economy. With pension checks as the primary source of revenue, the city sought to issue bonds for improving conditions of the town and began dealing with debt.

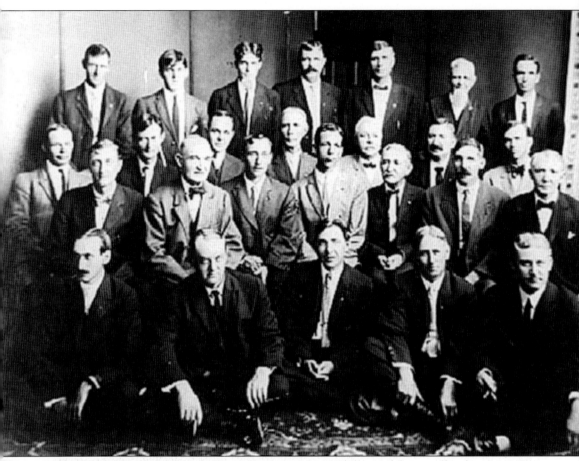

In 1913, the men of the Lynn Haven Business Men's Club posed for an official portrait. From left to right are (first row) Ed Wilbur, J.C. Baur, Paul Pomery, Ben Gessel, and Dr. Landis; (second row) Dr. W.G. Lowe, "Dad" Beach, Con Shives, Mr. Bell, T.J. Fringer, C.A. Sharp, and Tommy Johnson; (third row) Mr. Beckett, Mr. Campbell, Harry Lynn, Judge J.M. Hughey, Emory Truesdell, E.A. Titus, and Mr. Foster; (fourth row) Pearly Dillingham, Dave Davidson, Mr. Truman, L.J. Roberts, Tom Braten, Mr. Guard, and Harry Jackson. Organized in 1911 as the Business Men's League, the organization soon became known as the Business Men's Club. The first president, Frank McMullen, stated that the group's purpose was to "work individually, collectively, and cooperatively with every other interest toward the development and upbuilding of Lynn Haven and the welfare of her citizens." They sponsored events such as the 1914 "Get Together" picnic in the park to bring their work to the attention of the citizens. That same year, they launched an advertising campaign for Lynn Haven by printing envelopes bearing a photo of the town. They urged citizens to use them for their Christmas mail, thus sending the advertisements all over the country. (BCPL.)

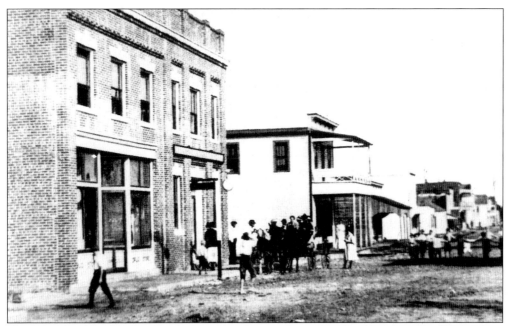

This brick bank building was completed in August of 1911. Its first president was W.H. Lynn, and its second was R.L. McKenzie. H. Bell was the head cashier. The building served the community as a church, schoolhouse, meeting hall, post office, and library. The community lacked a strong economic base to sustain its economy, and in 1915, the Lynn Haven Bank and Trust failed. (BCPL.)

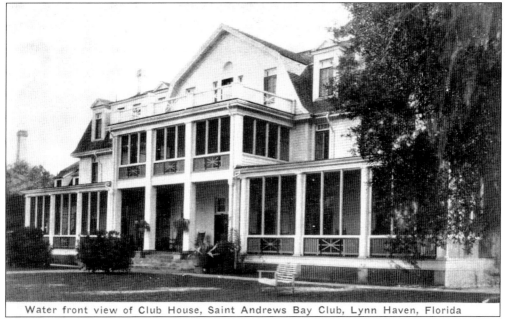

Water front view of Club House, Saint Andrews Bay Club, Lynn Haven, Florida

The Lynn Haven Hotel was completed in December of 1911. The grand, three-storied structure featured spacious porches that invited relaxation. It was also the site of gala parties, receptions, and formal dinners. Later, the hotel was converted to the Lynn Haven Sanitarium and became home to many of the veterans. The hotel burned in a spectacular fire in the late 1920s. (KTT.)

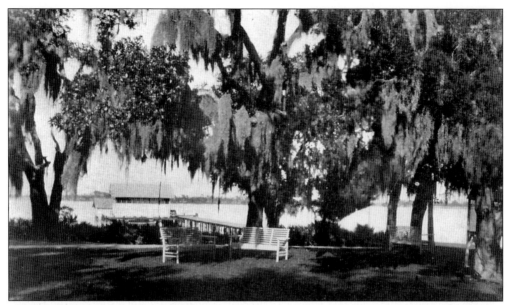

The scene from the porches of the Lynn Haven Hotel overlooked the waters of North Bay. Lynn Haven tried to build a tourist base, and therefore, a number of hotels were built in the first year to provide visitors, prospective buyers, and part-time residents with suitable accommodations. The business directory for 1912 listed nearly half a dozen hotels and rooming houses. (KTT.)

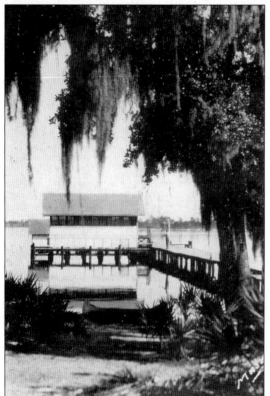

This view shows the hotel dock from the cultivated grounds of the hotel. Visitors to the hotel might well arrive by ferry or launch to begin their stay at the hotel. Many came to spend only the winter months. Even the developer, Lynn, found his wife would only come for such visits, although two of his children, Harry and Mary, became active residents. (KTT.)

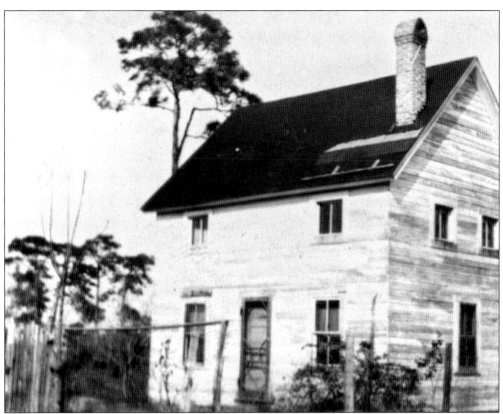

Many settlers imitated the homes of the North with this typical two-story box shape. The front door opened into a parlor with a kitchen and dining area behind it. Two bedrooms paralleled the parlor and dining room. The rooms all shared common walls. They soon learned that this design did not provide adequate ventilation. (BCPL.)

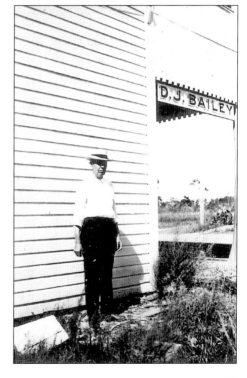

The Bailey family visited Panama City in February of 1911 and traveled out to Lynn Haven to see the lot they had purchased. Although they had not planned to live there, it seems they changed their minds. They returned the following September with their four children and all of their belongings. Mr. Bailey opened the town's first grocery store, called the Square Deal Grocery. Here he stands beside the store on Ohio Avenue. (BF.)

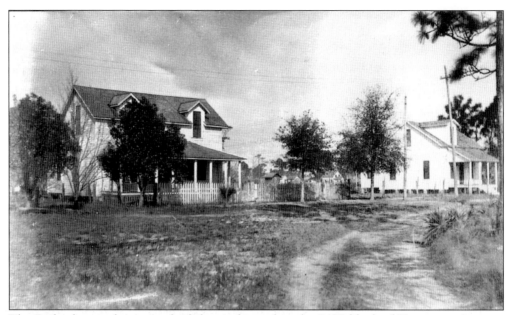

The Bailey home, shown on the left, was located in the 1400 block of Tennessee Avenue. Most homes needed some kind of fencing around them to keep animals out of the garden or house. (BF.)

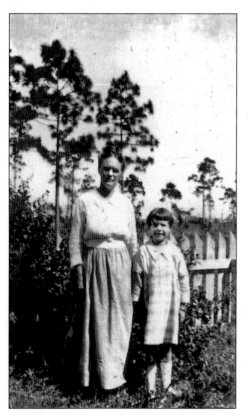

Pictured in front of their home are Mrs. Cora Alfreeda McDonald Bailey and her daughter, Florida Jane Bailey. (BF.)

This photograph of Ernest A. Titus and his wife, Esmah Etta, may well be their wedding portrait. Mr. and Mrs. Titus were among the earliest settlers to arrive in 1911. They were active in every aspect of community affairs and were proprietors of a grocery business. Mr. Titus, a native of New York, served over three years in the Civil War. Their home was located on Minnesota Avenue. (KTT.)

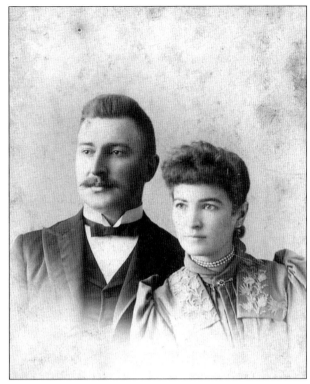

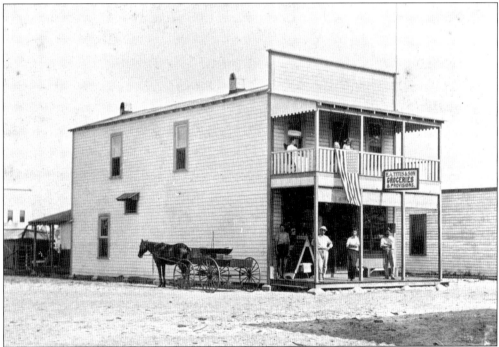

The E.A. Titus and Son Grocery, located on the northwest corner of Ohio Avenue and Eighth Street, promised "all kinds of eatables for man and beast." Son I.F. Titus served as city clerk through most of the 1920s. (KTT.)

The Roberts family moved from Idaho to Lynn Haven at the invitation of Mrs. Roberts's father, Civil War veteran Mr. Martin. Mr. Lee Jay Roberts constructed one of the first buildings in Lynn Haven. It was located on the northeast corner of Ninth Street and Florida Avenue. In 1922, the building was purchased by the Odd Fellows Scarlet Lodge and has remained their meeting hall to the present time. (RFC.)

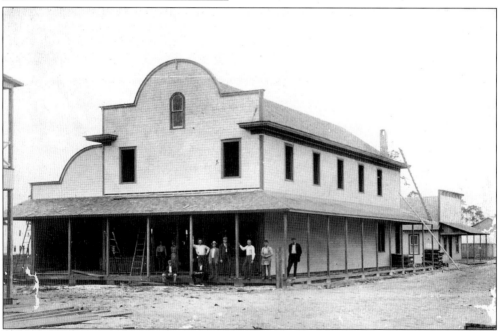

Mr. L.J. Roberts can be seen on the porch of Roberts Hall during its construction. The first floor of the building housed a store, but longtime residents most remember the dances held each Friday night on the second floor. Ruth Roberts recalled that the family lived in a shed in back of the construction. They were happy to see the hall finished so that their father would build their house. (RFC.)

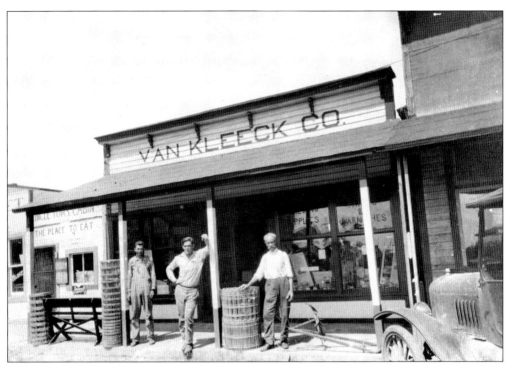

Van Kleeck Co. hardware store was located first on Florida Avenue in this frame building. Its merchandise was vital to the building that was going on in the colony. The store delivered purchases by wagon to all parts of town. At one time, Vivan Roberts was hired to drive the delivery wagon. Roy Van Kleeck opened a second store in Panama City in 1922. (KTT.)

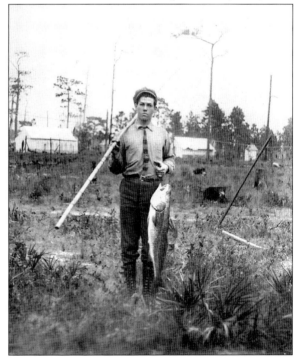

Life was not all work and no play. Here, young Roy Van Kleeck shows his catch. Fishing, both salt and freshwater, was one of the most frequent pastimes for young and old alike. Some of the old men spent their entire day fishing and socializing on the dock. Reports from the *Tribune* indicate that very large fish and large catches were common. (RFC.)

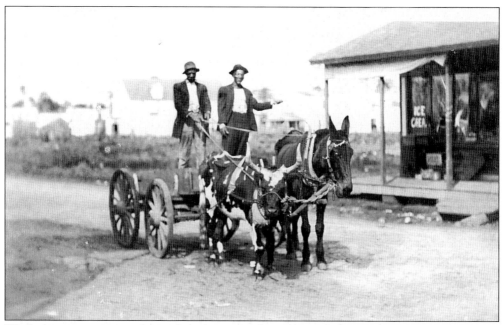

Workers were in great demand with so much construction in progress. Newspapers in surrounding communities carried advertisements for workers to come to Lynn Haven. Here, two workers bring a wagon to pick up materials. Note the wagon is pulled by a mule and an ox. (RFC.)

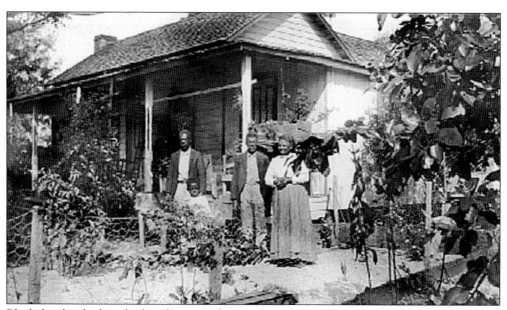

Black families had made their home in the area long before the arrival of W.H. Lynn and his development. Many worked in the turpentine industry and held both school and church services in their homes. Here is the home of an unidentified black family. (BCPL.)

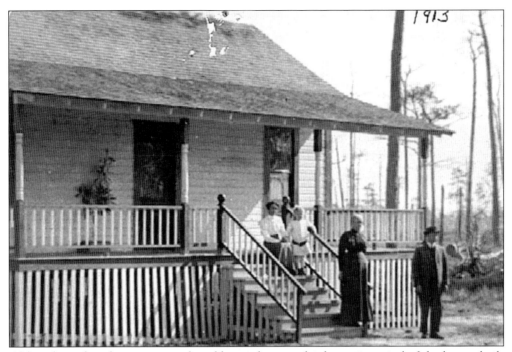

Although neither the owner nor the address is known, this house is typical of the homes built in the colony. There were adjustments to be made between the Northern home and the Southern style. At first, the newcomers made no provisions for heat during the winter months. Eventually, the colonists learned it was best to build off the ground and leave spaces for the summer breezes to pass through. (BCPL.)

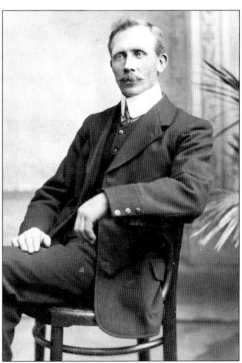

Donald Mowat and his wife, Margaret, emigrated from Scotland to Canada in 1911. The next year, their first son was born, but the child and his mother suffered so severely from bronchitis during the cold winter that their doctor advised a warmer climate might be their only chance of survival. During the week of Christmas in 1913, the young family arrived in Lynn Haven. This photograph was taken before Donald left Scotland. (MFC.)

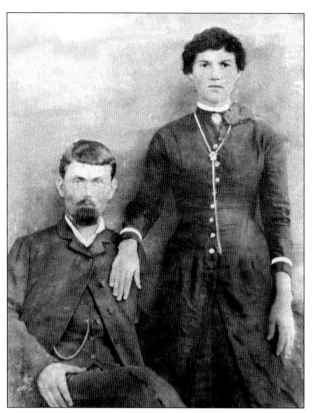

George Washington Hobbs and his wife, Annie Melvin Hobbs, moved from Georgia to Bay Head, Florida, which was then known as Bennett, in 1905. From there, they moved to Lynn Haven, along with seven of their children. (LT.)

The Hobbs family's first home (pictured below) was located on Alabama Avenue. They lived in several other houses, including one in Panama City. Eventually, they settled into a Virginia Avenue home. (LT.)

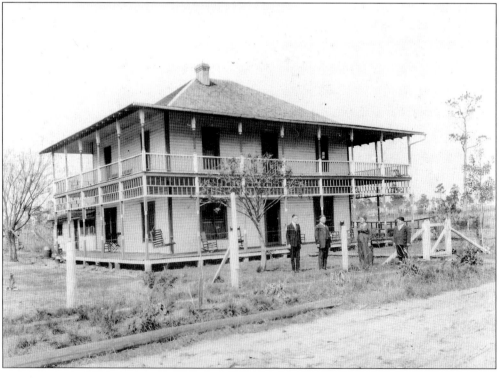

These two beauties are the daughters of George and Annie Hobbs. They both became homemakers in Lynn Haven. Standing is Carrie Hobbs Maxwell, and seated is her sister, Anna Lee Hobbs Jencks. (LT.)

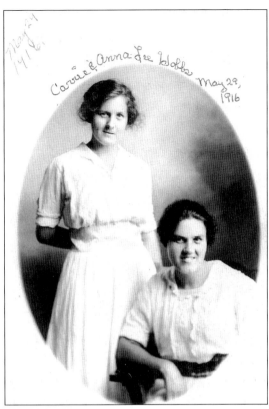

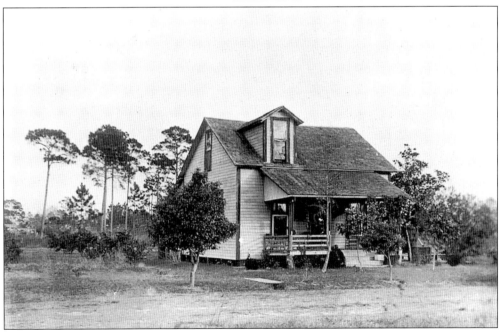

This house on Virginia Avenue became the permanent home of George and Annie Hobbs. Although greatly enlarged, the home today is a model of preservation efforts. It is still home to a member of the Hobbs clan. (LT.)

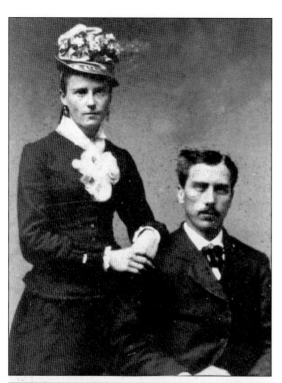

Walter Cabasa Jencks and his wife, Lillian Waddington Jencks, shown here in their wedding photo, moved to Lynn Haven in 1915. (LT.)

Pictured in 1916 is Dr. William Krape, seated on the front seat of his stylish buggy with his driver. Mr. and Mrs. W.C. Jencks are riding in the middle seat, and those in back are unidentified. The occasion is unknown, but the party seems to be dressed for a special event. (LT.)

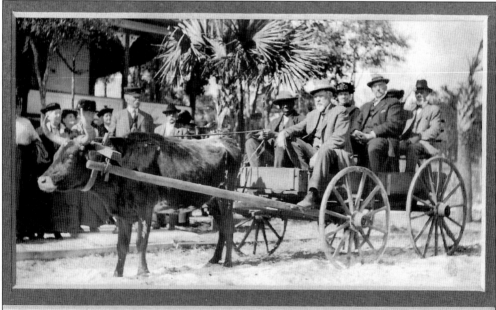

Early Lynn Haven

Anna Lee Hobbs Jencks may be introducing nine-week-old Guy Jr. to his big brother, W.C. However, the baby is crying and big brother does not seem to want anything to do with him. Other pictures indicate the two became constant companions. (LT.)

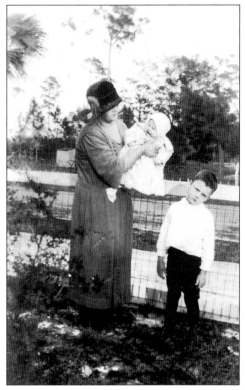

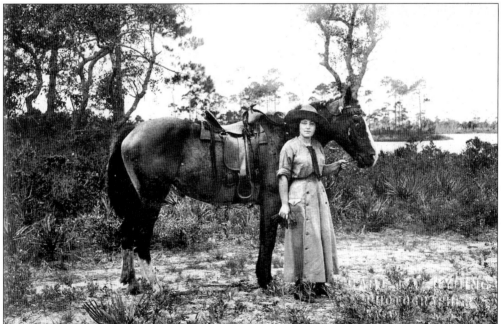

The attractive woman pictured here around 1914 is Nina Roberts Van Kleeck. She was the oldest daughter of Lee Jay and Mary Roberts and was married to Roy Van Kleeck, owner of Van Kleeck Co. hardware store. Nina's brother was Vivan Roberts and her sister was Ruth Roberts Peach. (RFC.)

THE BAYERA

Published by the Students of the

BAY HIGH SCHOOL

VOLUME I. - - - - BOOK I.

Lynn Haven, Florida, May, 1917

—— THE STAFF ——

Editor in Chief - - - - - Kenneth Hait

Assistant Editor in Chief - - Willie Edwards

Business Manager - - - Norman Bailey

Advertising Manager - - - Frank F. Fox

Circulating Manager - - - - Minnie Milton

—— Associate Editors ——

Fort Smith Maxwell Wells Lillie M. Harrison

Maggie Milton Darrel Brown

Floyd Harrison

OUR COLORS

Orange and Black,

Orange and Black,

Clear the track

For the Orange and Black.

For one year, Bay County High School was located in Lynn Haven. When Bay County was formed out of Washington County in 1913, rivalry to be the site of the high school was fierce. In special elections, there was no clear majority. William Lynn pledged land and $2,500 toward construction. Approval to open a high school came in 1916, and this is the cover of their yearbook, the county's first. The class of 1917 was the only class to complete their education in Lynn Haven as Bay High School. (LT.)

J. Boswell Atkinson arrived in 1915. He was a flyer and somewhat of an adventurer. In 1926, he married Elizabeth Mae Brandenburg. The wedding took place at the bride's home on Michigan Avenue. After a bridal supper for 100 guests served at the home of her grandfather, Frank McMullen, the couple left for a tour of Florida in their new Chrysler, a gift from the bride's mother. In the 1930s, Atkinson operated an airfield south of Lynn Haven known as Atkinson Field. Before Tyndall Field was completed, military planes landed there. Later, Atkinson donated the land to the county for the Bay County airport, Fannin Field. (SA.)

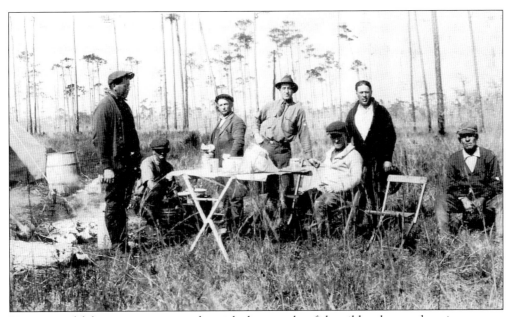

Hunting and fishing trips were popular with the men, but fish, wild turkey, and venison were a welcome addition by all family members to the dinner table. This hunting party appears to be enjoying themselves in comfortable surroundings. J.D. Atkinson is fourth from left. (SA.)

Shown here is Frank McMullen, whose granddaughter married J.B. Atkinson in 1926. McMullen owned the amusement hall and the Alvin Theater in town. He was active in civic affairs and in organizing the Business Men's Club. McMullen and J.B. Atkinson made a movie called *Grandpa and Bobby in Florida*. The plot was centered in Bay County, and funds raised from showing the movie in Northern cities were used to buy books for Lynn Haven's library. (SA.)

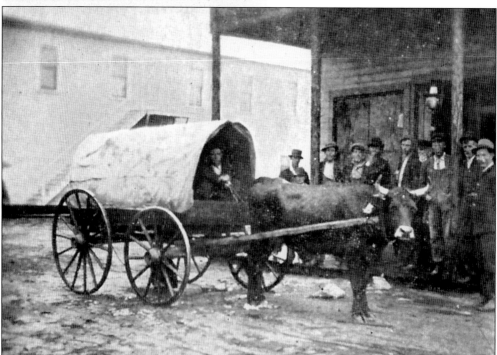

This "horseless carriage" was photographed in the business district. Not quite the later type of horseless carriage, this one seems to have attracted attention in early Lynn Haven. (RFC.)

Young Perry Kyser, shown here, delivered mail by boat around North Bay. He picked up mail in Southport and crossed the bay to make a delivery at the Lynn Haven Hotel dock. Then he traveled east along the shoreline to make a delivery at the Gay family dock. From there he headed up to Bay Head where he lived and finished his mail route. (GK.)

Annie Miller married Perry Kyser in 1920 and they made their home in Lynn Haven. They opened a restaurant and also ran a taxi service. They held the distinction of being the third Southern family to move into the GAR settlement. (GK.)

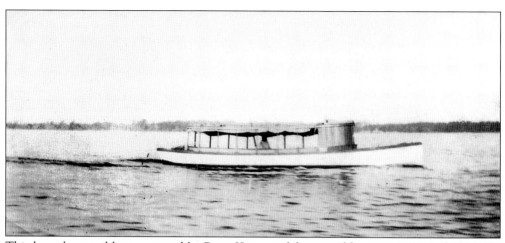

This long, low mail boat was used by Perry Kyser to deliver mail between 1917 and 1921. He often carried passengers or supplies as well. (GK.)

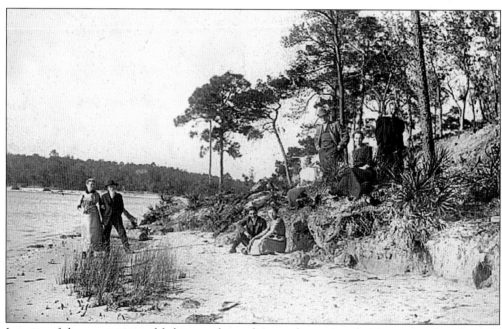

In spite of the constraints of fashion and morality, settlers enjoyed visits to the shoreline. Of course, this group could hardly be called swimmers or beach bathers. (BCPL.)

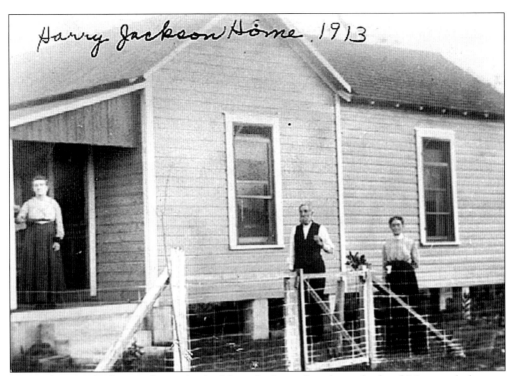

Harry Jackson Home. 1913

Shown here is the home of civic leader Harry Jackson, for whom the local Masonic lodge was named. (BCPL.)

This is the home of Dr. O.E. Giles, who was a physician, politician, and community leader. Among one of the first groups of veterans to come to the area, he was defeated for the office of mayor by J.M. Hughey in the city's first election in 1913. (BCPL.)

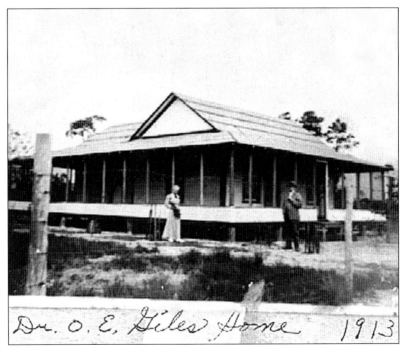

Dr. O. E. Giles Home 1913

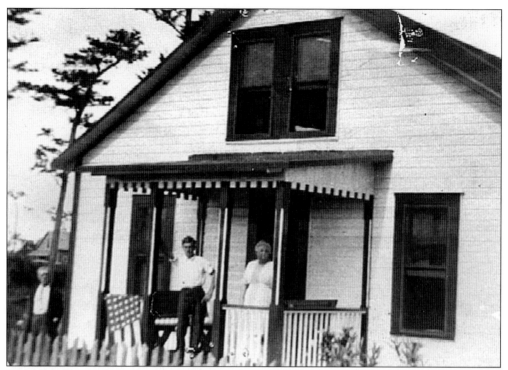

One of the first to be built in Lynn Haven, this early home belonged to the Merrill family and was located on New York Avenue between 13th and 14th Streets. (BCPL.)

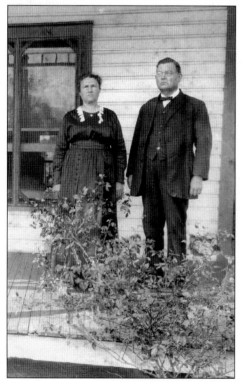

Mr. and Mrs. G.W. Hobbs stand together as they mark their 25th wedding anniversary. The couple raised eight children in Lynn Haven, and many of their descendants are still living in the community. The couple was together for over 50 years. (LT.)

Four

THROUGH THE YEARS

Your day is past, your task is done; the memory of what you've won
for civilization we hold dear, so here's to you—the pioneer.

—Cora Bailey

Speaking before the Old Settlers Club in 1929, Mrs. Cora Bailey recounted her memories of early Lynn Haven and compared that city with its present condition. She spoke of her first impressions upon arrival in the town and touted the accomplishments made in less than two decades. Indeed, great strides had been made. There were some 56 different businesses. Although the population was below its 1913 peak, it was stable primarily because a considerable number of Spanish-American War veterans had settled in the community. Few of the Union veterans were still living.

The newspaper *Lynn Haven Free Press* also promoted the town by boasting of the volunteer fire department, the theater, the community building, the two dairies, four grocery stores, and a clean, healthy city. Considering the effects of the collapse of the Florida real estate boom in the mid-1920s, it is remarkable that the settlement was still a viable place to live.

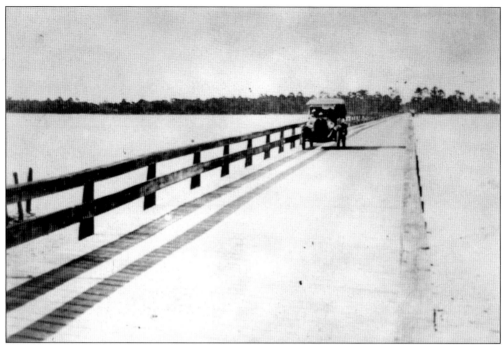

A wooden bridge opened to span the waters between Southport and Lynn Haven in 1925. It was the first public toll bridge in the county. Mrs. W.J. Harrison and her son, Wallace, were employed by the county as bridge tenders with a salary of $75 per month. (BCPL.)

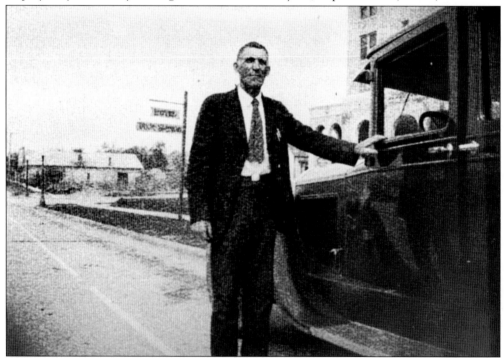

The taxi service operated by C.A. Sharp made trips into Panama City on a daily basis. It could also be hired to convey passengers to nearby towns when necessary. (BCPL.)

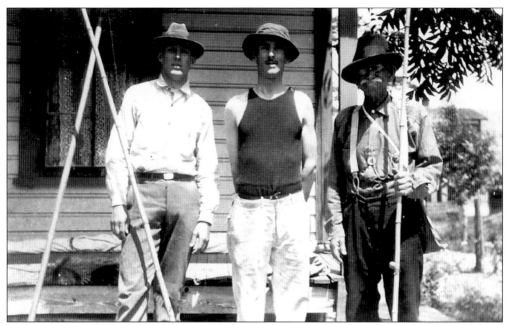

Fishing was a popular pastime among the settlers. In this snapshot, titled "Gone Fishing," Methodist minister Quincy Murphree (left), Leslie Porter (center), and Uncle John Porter look as if they are ready for a day of fishing. (LHUMC.)

Pictured is Guy Jencks Sr. with his fish. It was not uncommon for residents to bring home a string of fish like this every day. It was reported that one group who ventured into the Gulf returned with over 1,000 pounds of red snapper. (LT.)

This photograph was taken around 1926 on the steps of the Methodist church. Guy S.D. Jencks Sr. is holding Guy Jr. W.C. is seated between his father and Uncle Quincy Murphree, who was pastor of the church at the time. (GJ.)

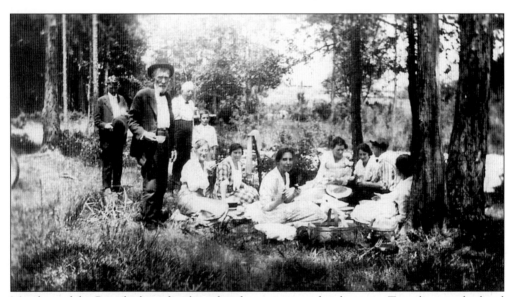

Members of the Brandenburg family gather for a picnic under the trees. Traveling up the local creeks to visit farms or settlements along the way was a popular excursion. Elizabeth Brandenburg, granddaughter of Frank McMullen, married J.D. Atkinson in 1926. (SA.)

It was said that a town could not expect to be any sort of tourist destination without a golf course. In 1926, Minor Keith opened a golf course, designed by Donald Ross, on the site of the Gay plantation. (BCPL.)

MINOR C. KEITH

"Lives of great men all remind us
We can make our lives sublime
And departing leave behind us
Footprints on the sands of time."

Construction is underway for the golf course; this is the 17th fairway. Notice that the course followed the shoreline of the property. It was reported in 1926 that an average of 40 players per week played the course and that the largest number of them came from locations in Alabama. (BCPL.)

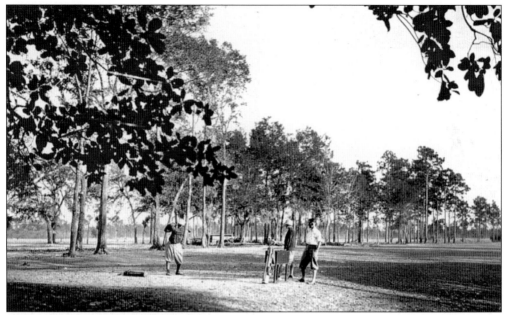

Here, some golfers enjoy the pleasures of a day outdoors in the company of good friends and competitors. A small greens fee of $1 permitted a player to use the course and clubhouse for an entire day. Still, it was not exactly public, since players needed to get a courtesy card from the Keith organization at the company offices. (BCPL.)

Dressed in the proper attire for the day, these golfers spend an afternoon on the links. The golf course was a major asset to Lynn Haven. The first tournament was held in 1927, and golfers came from all over to play. Merchants donated prizes for the event, but the most impressive was the silver trophy given by Mr. Walter Sherman to the champion. The tournament, known as the Sherman Invitational, has been held on the first weekend in May ever since. It is the oldest continuously held golf tournament in the state of Florida. The first champion was Mr. D.A. Vann. Mr. E.F. Johnstone of the Mobile Country Club won the second tournament. (BCPL.)

A solitary Minor Keith walks the course. He could be reviewing his golf game, or he could be pondering his accomplishments. (BCPL.)

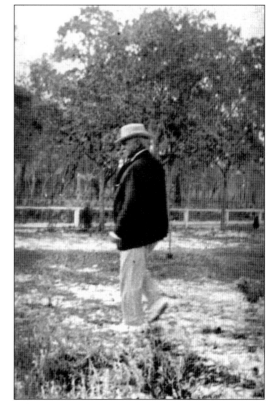

Once the home of the Leslie Gay family, this house was remodeled and served as the first clubhouse. It was the scene of a lavish dinner party given to celebrate the opening of the golf course in February 1926. Through the years, it served as a center of social activities and meetings. These warmly dressed ladies have arrived for some winter function. (BCPL.)

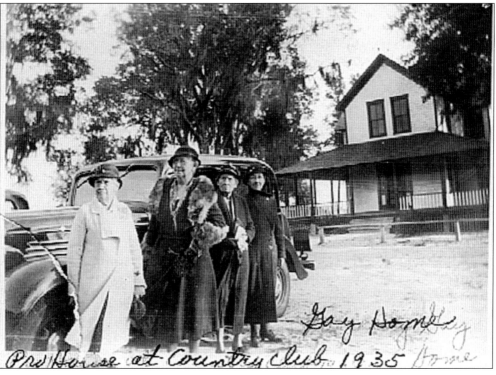

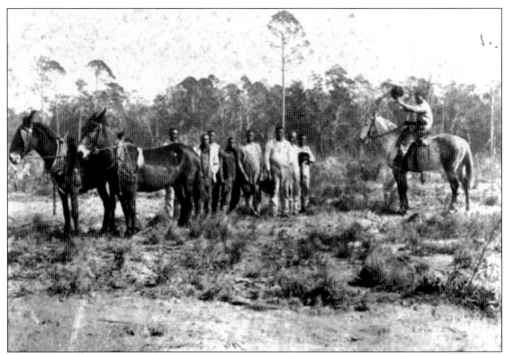

Land is being cleared for the construction of Bob Jones College in this photograph. The site was on a point of land jutting into North Bay, just east of the golf course that was under construction at Lynn Haven. (BCPL.)

Popular Alabama evangelist Bob Jones held regular revivals in Panama City during the early 1920s. He monitored the growth of Lynn Haven and determined it would be the place to locate his Christian college. The college opened in 1927, but it moved to Cleveland, Tennessee, in 1933. (BCPL.)

Alice M. Ward is standing in front of the auditorium under construction at the Bob Jones College in 1927. She worked at the college on a part-time basis until she became the librarian in 1929, where she stayed until the college moved in 1933. She also kept journals and wrote stories and accounts of life in Lynn Haven. (BCPL.)

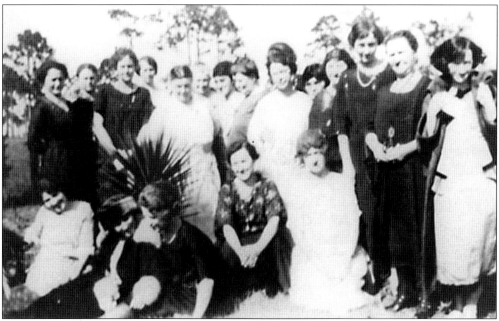

This group of well-dressed ladies are members of the Presbyterian Circle of Ruth, making a visit to Bob Jones College at College Point around 1930. Organizations in Lynn Haven were quite supportive of the college. Groups often visited students or brought flowers to decorate the dormitories. The pastor of First Presbyterian Church of Lynn Haven was also the college's history professor. (BCPL.)

In 1923, Cora Bailey and her daughter, Jane, posed in the parlor of the Bailey home on Tennessee Avenue. If it were not for the accounts of daily life in Lynn Haven so carefully entered in the diaries of Cora Bailey, it would be difficult to understand what life there was really like for those who built the town. (BF.)

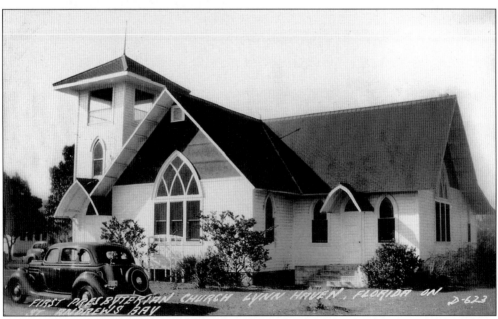

The First Presbyterian Church's outside appearance changed little, but the interior was altered in 1929. The main auditorium was extended 20 feet to the west, sloping floors leveled, and the pulpit and choir loft moved from the east to the west end of the building. (MFC.)

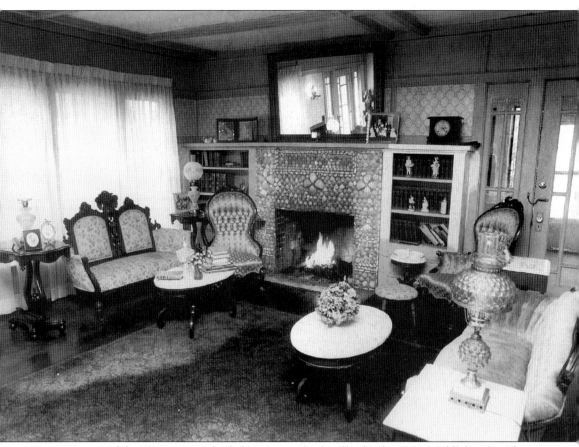

Here is a view of the Victorian parlor belonging to the family of Judge D.K. Middlebrooks. The home was located on 12th Street, and its grounds covered almost a city block. Judge and Mrs. Middlebrooks had two daughters, Catherine and Marie, who also lived in the home. Catherine Middlebrooks Lloyd, best known as Kitty Lloyd, lived in the house until her death in the late 1980s. Notice the intricate fireplace mosaic made of seashells. The house was demolished in the 1990s. (LHPL.)

Shown is the home of Perry and Annie Kyser at 607 Alabama Avenue. Warmly dressed, Gene and his sister, the children of Perry and Annie, enjoy their first encounter with Lynn Haven snow in 1932. (GK.)

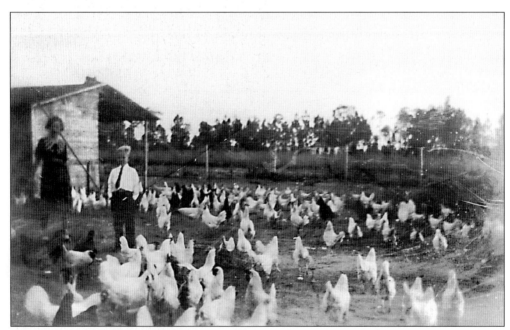

The Kyser family's chicken farm was located behind their Alabama Avenue home. Young Gene watches his mother, Annie, feed the flock. (GK.)

Dressed in their Sunday best, these ladies are attending a birthday gathering. The young woman fifth from the left on the back row is Anna Jencks. Her young daughter, Elizabeth Ann, is the little girl on the front row. (LT.)

Here, Guy Jencks Jr. is standing on the front porch of the home of his grandmother, Annie Hobbs, around 1926. (GJ.)

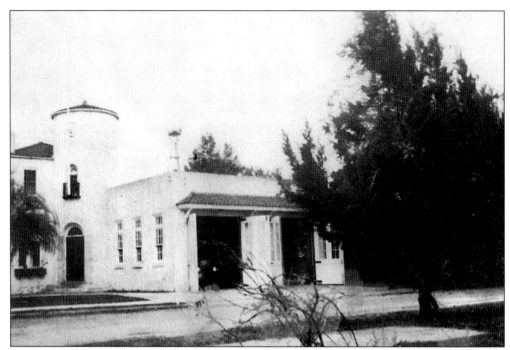

Mr. Henry Hey was selected as architect for Lynn Haven's city hall in 1927. The Spanish-style building, located at the corner of Ohio Avenue and Ninth Street, was constructed of hollow tile and stucco. The tax collector's office, a vault for records, and a council chamber, as well as the jail and fire department, were housed in the building. Completed in 1928, this building still serves as the Lynn Haven City Hall. (MFC.)

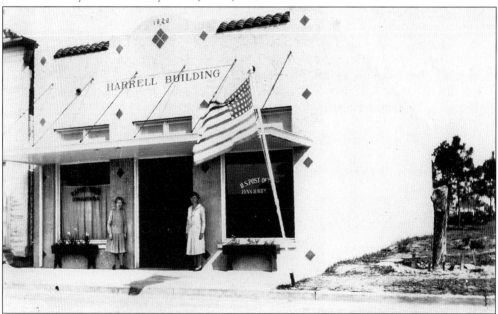

The U.S. Post Office was located in this building on Ohio Avenue during the 1930s. On either side of the door are two of the three Cooley sisters, Ernestine and Irene, who served as postmistresses. (RFC.)

HOUSE BILL NO. 1033

AN ACT TO ABOLISH THE PRESENT CHARTER AND MUNICIPAL GOVERNMENT OF THE CITY OF LYNN HAVEN IN BAY COUNTY, FLORIDA, AND TO GRANT IN LIEU THEREOF A NEW CHARTER AND CREATE A MUNICIPAL GOVERNMENT UNDER THE NAME OF CITY OF LYNN HAVEN, FLORIDA, AND TO PROVIDE FOR ITS JURISDICTION, POWERS, PRIVILEGES AND IMMUNITIES.

Be It Enacted by the Legislature of the State of Florida:

Section 1. That the present charter and municipal government of the City of Lynn Haven in Bay County, Florida, be, and the same is hereby abolished and repealed, and a municipality to be known as the City of Lynn Haven, Florida, is hereby created and established within and covering the following territorial limits in said County.

Commencing on the intersection of the center line of the North arm of St. Andrews Bay with the half section line dividing the East half and the West half of Section Three (3), and running thence South to the Southern boundary line of Section Ten (10); thence West to the Southwest corner of Section Nine (9); thence South to the South-east corner of the North-east quarter of the North-east quarter of Section Seventeen (17); thence West to the South-west corner of the North-east quarter of the North-west quarter of section Seventeen (17); thence North to the center line of the North Arm of St. Andrews Bay; thence in a North-easterly direction along said center line to point of beginning, all being in Township Three South, Range Fourteen West.

The aforesaid territorial limits may be changed, enlarged or contracted in the manner provided by the general law. The jurisdiction of the City of Lynn Haven shall extend over all persons and property, franchises and privileges located or coming within said limits, and over and upon any property the City may own or possess for municipal purposes outside of said limits.

Section 2. The terms "City of Lynn Haven" or "City" as hereinafter used in this Act shall refer to the new municipality hereby created and the words "Old City" shall refer to the old municipality which is hereby abolished.

Two full years after Lynn Haven's founding, the citizens requested a charter. People felt the time had come for them to assume the responsibility of their own government and shoulder the burden of public improvements. It is possible that the citizens felt they could do more for the city than the St. Andrews Bay Development Company could at that time. Rep. L.L. Howell introduced the charter bill to the Florida Legislature in April 1913. First elections were held in June. The city was to be governed by an elected mayor and five elected aldermen. Their first organizational meetings were held in the office of J.M. Hughey, who had been elected mayor. Until 1928 when the city hall was built, a small room at the rear of Roberts Hall served as the city hall. In 1927, Lynn Haven petitioned the state for a new charter that would create a city commission form of government. House Bill No. 1033 was approved by the governor on May 27, 1927.

The home of J.D. and Elizabeth Atkinson was located at 1011 Michigan Avenue. Their little son Carlos is playing in the yard. Atkinson was an aviator who operated the first airfield in the county. Later, he donated land for the county airport named Fannin Field. (SA.)

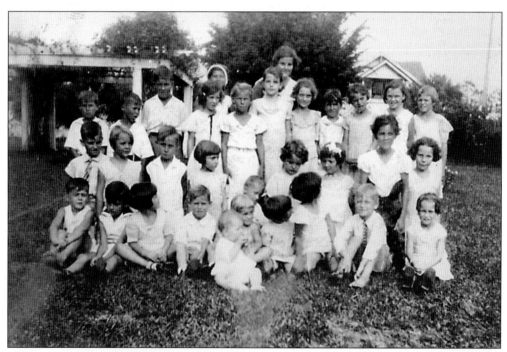

There were plenty of children in the community. A group of children from the Michigan Avenue neighborhood seem to be enjoying a party. (SA.)

Five

THE DEPRESSION YEARS

In all your plans for Thanksgiving will you try and remember that there is a worthy object for your generosity right in your midst? The sanitarium is in hard straits just now having lost their reserve fund due to bank failure, having patients who could not pay and for whom the county could not provide— homeless and helpless, common humanity would not allow them to be turned out.

—*Lynn Haven Free Press*, November 25, 1933

No one escaped the Depression. Even though the 1920s sounded quite prosperous with construction of the golf course, college, and city hall, the city was in financial distress and attempted to raise funds by issuing bonds. Lynn Haven's finances through the 1930s were controlled by that debt. Many of those who had planted orchards saw fruit prices drop so low that it was better not to harvest. Severe weather hurt the gardens that had fed many residents. The full-time population in 1930 was 778. Had the census been taken during the winter tourist season rather than April, it would have been greater but far from the numbers of those first boom years. Winter visitors were vital to the economy. Those who did become residents were retirees seeking a community of "old people."

Now the challenge was survival. Just like people everywhere, they did the best they could, worked hard, helped one another, and hoped for better times to return.

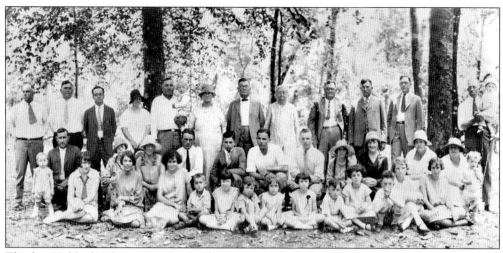

The first Hobbs family reunion was held at Bayhead, Florida, in 1926. Pictured from left to right are (front row) ? Swearington, Fleta, Estell, Emory Gay, Inez, Gladys, Catherine, Tines, Carl Jr., unidentified, W.C. Jencks, unidentified, and Louise; (middle row) Lamar, Carl, Liza, Evie, John, Bascome, Russell, Stedman, Daisy, Carrie (Hobbs) Maxwell, Anna Lee Hobbs Jencks, Stella Swearington (cousin), and unidentified child; (back row) Walter, Wesley, ? Swearington, Alavern, Emory, Gene, Mama and Papa Hobbs, Great-grandma Caroline Hobbs, Uncle Preston Hobbs (Papa Hobbs's brother), Olen, D.E. "Max" Maxwell, Guy S.D. Jencks, and Guy Jencks Jr. Otis Hobbs Brigman was absent. (LT.)

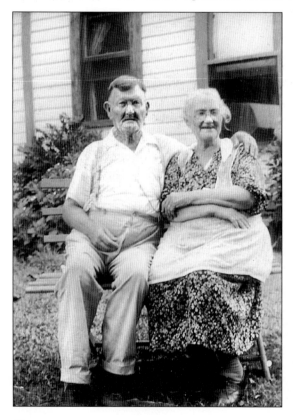

Mama and Papa Hobbs are still together after 50 years of marriage. (LT.)

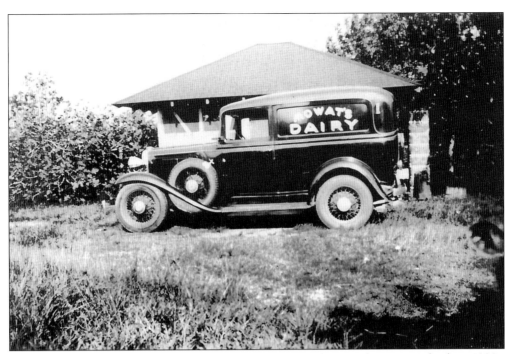

After freezing weather severely injured the crops of local citrus farmers in the late 1920s, Donald Mowat entered the dairy business in 1932. Pictured here is his car with an advertisement for the dairy on the door. (MFC.)

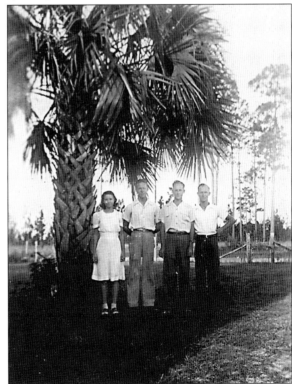

The four children of Donald and Margaret Mowat stand together in the late 1930s or early 1940s. World War II would separate them forever. From left to right, they are Betty, Jim, Don, and Bill. (MFC.)

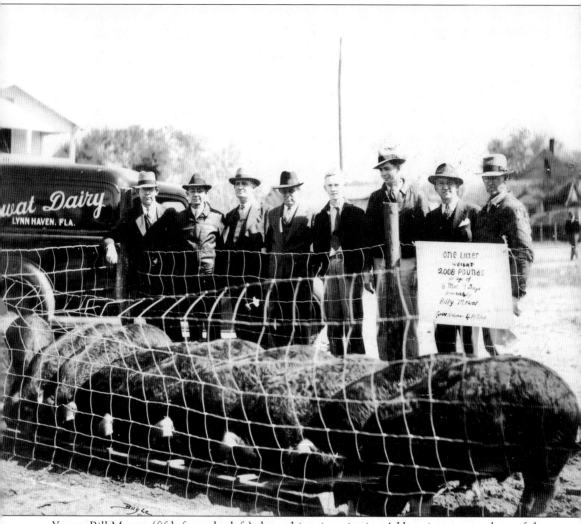

Young Bill Mowat (fifth from the left) shows his prize-winning 4-H project to members of the community. From the banner it appears that one liter of pigs has grown to a total of 2,000 pounds. Also in the picture are John Hentz, county agricultural agent; W.B. Gainer, president of Bay Bank; Mr. Miley; and some members of the chamber of commerce. (MFC.)

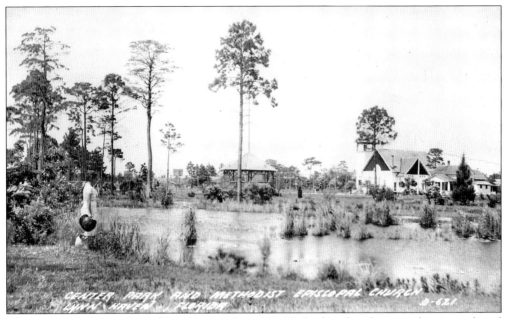

This view looking east from Ohio Avenue shows the Methodist church across the city park and pond. The Gazebo, site of concerts and community picnics, can also be seen. (TB.)

The Bludworth family rented a small house facing Ohio Avenue and located behind the Foote home. The building that was their home was later moved to Michigan Avenue and still serves as a shed. Young Talley Bludworth rides his tricycle near the corner of Florida Avenue and Fifth Street. The house behind him is the home of his family's landlord. (TB.)

Here the Bludworth family stands together beside the family car. Walter Bludworth is holding his young son, Talley, with his wife, Gertrude, on his left and Aunt Perla Cauley on the right. (TB.)

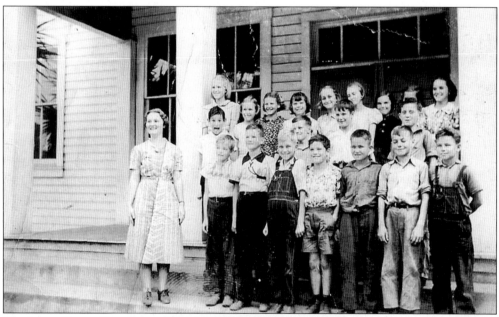

The Lynn Haven Elementary School's fifth-grade class of 1939 is shown in this photograph. Their teacher is Gertrude Bludworth. She first taught this group of children when they were in the third grade; when they were promoted to fourth, she moved up with them. Again, when they moved to fifth grade, she was once again their teacher. The little boy wearing overalls at the end of the front row is Gene Kyser. (GK.)

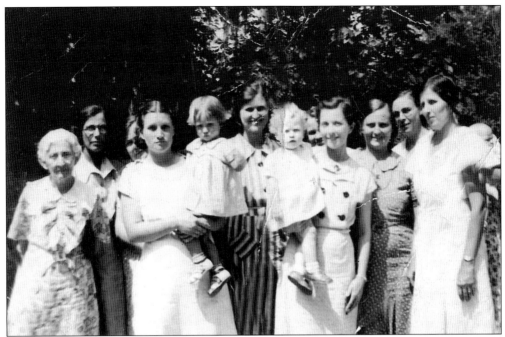

These ladies are members of the First Baptist Women's Missionary Union in 1936. At that time, the Baptist church was located at the corner of Ninth Street and Virginia Avenue. The church was later rebuilt on Ohio Avenue. The Baptist women were active in civic endeavors from the founding of their congregation in 1913. They were widely praised for the meals they prepared whenever there was a community fund-raising effort. (PK.)

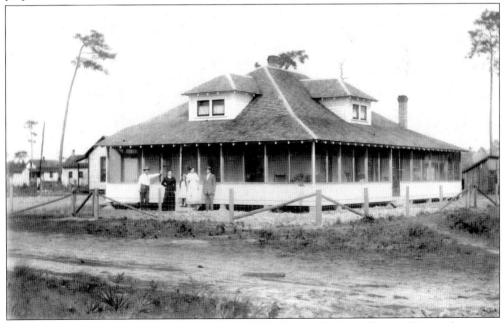

This is another house typical of the spacious style built in early Lynn Haven. Notice the screen porch surrounding the home and the windows on all sides of the second floor. The owner, although unknown, did appreciate the value of summer breezes. (BCPL.)

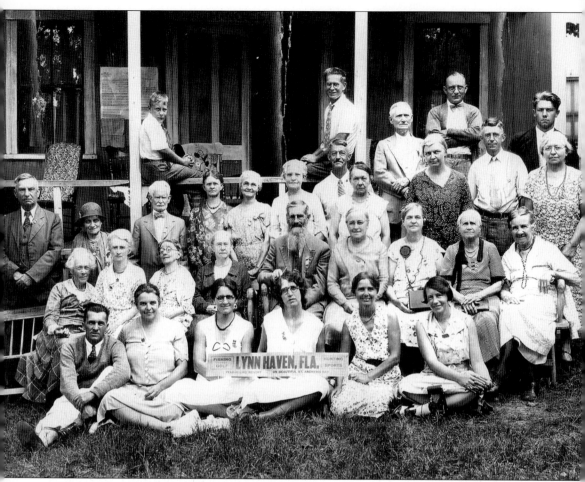

Although not identified, this smiling group looks happy to be in Lynn Haven. They are seated at the entrance to the Lynn Haven Sanitarium, formerly the Lynn Haven Hotel. The sign reads "Lynn Haven, Fla., Year-Round Resort on Beautiful St. Andrews Bay" and promises fishing, golf, hunting, and sports. The sanitarium advertised that it was "a small institution for the care of semi-invalids, especially the veterans of the Civil War, spending the winter in the South and having no one to care for them." The cost was $35 and up, depending on the condition of the patient, but those with contagious diseases or insanity need not apply for a reservation, according to the advertisement. (MJ.)

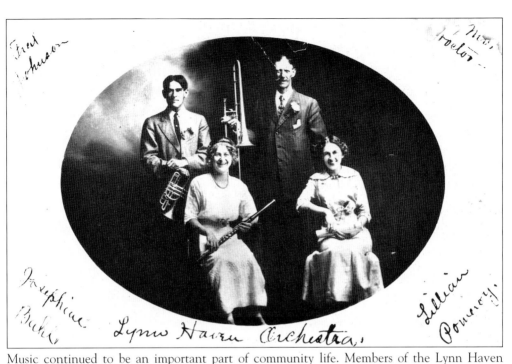

Music continued to be an important part of community life. Members of the Lynn Haven Orchestra shown on this picture postcard are (standing) Fred Johnson and Mr. Proctor; (sitting) Josephine Buhle and Lillian Pomeroy. (BCPL.)

Violet Hayward began her teaching career when she was hardly older than her students. She is seen here with a large class of elementary children outside the school that was built in Lynn Haven during the 1930s. She taught not only academics but violin and music as well. (BCPL.)

Mrs. Bertha Gessel and Mrs. Geneva Jackson are pictured in the yard of Gessel's home in Lynn Haven. This home was located at the corner of Indiana Avenue and Fifth Street. The Gessel family moved into this home around 1928 from their first home, which was located just across the street. (BCPL.)

This Baptist Sunday school class enjoys an outing in the early 1930s. Most activities for teens in Lynn Haven were organized through youth programs in churches. (PK.)

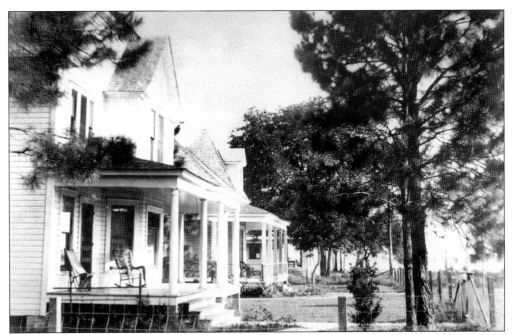

The row of houses seen here are considered examples of the finest homes in the community. They typify the gracious and relaxed lifestyle that the community wanted to project, especially when they were advertising the town to potential residents. (BCPL.)

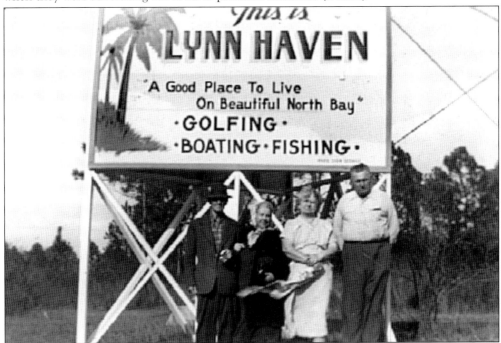

These four citizens are certainly proud to live here or have enjoyed their stay. Early residents were not embarrassed to proclaim their civic pride and love of their hometown. It was not unusual to find poems written by residents and published in the weekly newspaper that expressed their feelings. Indeed, it is "A Good Place to Live." (BCPL.)

Roberts Hall was sold to the Independent Order of Odd Fellows Scarlet Lodge #75 in 1922. During the Depression years, they hired an itinerant artist, who was in need of money, to paint murals on the walls of the second-floor meeting hall. J.W. Zelm portrayed a location described in the Bible in each of his six paintings. (EWG.)

In spite of leaks along the walls of Roberts Hall, these murals are in wonderful condition. The colors have stood the test of time and are quite clear. This scene is of the River Jordan. (EWG.)

Six

RECOVERY

The people congregate
From every state
To visit and to play
Some to fish and
Some to loll on the
Shores of St. Andrew Bay.

The climate is so lovely here
And the people are so friendly
They smile and say how
Glad I am to see you here,
And when did you come?

—Genevieve Pierce

They weathered the Depression. As a result of the WPA, Lynn Haven gained a new elementary school. Now, the war years would begin to restore prosperity to much of the area. People began to pour into Bay County in the early 1940s, first for the construction of an air field and the opening of flight school there, and then as troops from nearby military bases who marched through the area. General McArthur found that the old wooden bridge across North Bay into Lynn Haven could hardly bear the weight of his equipment. The opening of Wainwright Shipyard brought hundreds into the area seeking housing. The U.S. Navy opened a small training center on St. Andrews Bay. Lynn Haven held its own. The new, modern bridge across the bay opened new opportunities. The chamber of commerce formed a tourist committee that advertised the community far and wide. Citizens were so supportive they made donations to the advertising campaign. Residents were ready to meet the needs of their community, whether it was a fund-raiser at school or the all-volunteer fire department. When the war ended, Florida felt the effects of returning service men. Just as those first veterans sought their place in the sunshine, many in this new group of veterans wanted to settle in Florida, too. Indeed, some found a home in Lynn Haven.

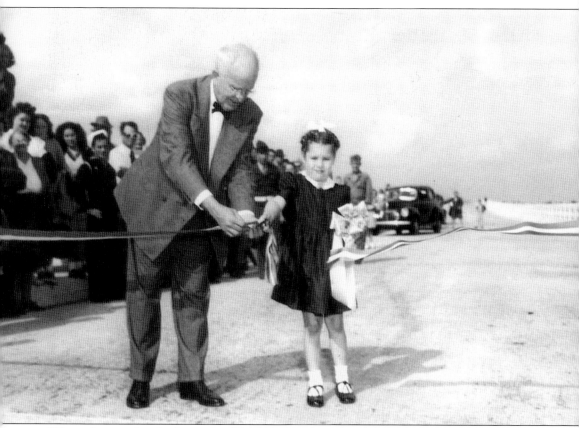

When the wooden bridge across North Bay was replaced by a modern concrete span in November 1946, it was named for Mr. D.J. Bailey, as a tribute to an honest man who always gave his neighbors a square deal. Here, his granddaughter Rachel Ellen Clothier cuts the ribbon to open the bridge. Assisting her is the former state senator from Chipley, Mr. Olin Shivers. (BF.)

By virtue of his early arrival and years of community service, D.J. Bailey was considered a founding father of Lynn Haven. (BF.)

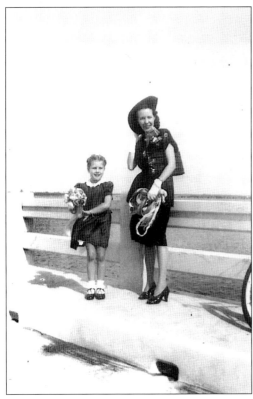

Rachel Clothier is shown here standing on the brand new bridge with her mother, Jane Clothier. (BF.)

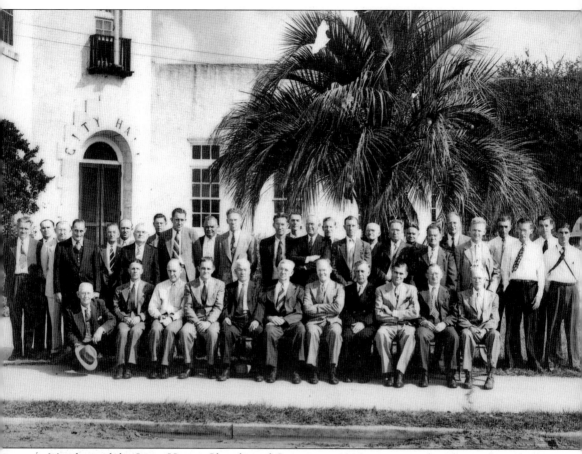

Members of the Lynn Haven Chamber of Commerce 1946 are pictured in front of city hall. From left to right are (front row) H.V. Harpman, A.L. Kinsaul, Jack E. Cooke, Ray Jacobs, John T. Fendley, John Cooley, Charles Marks Jr., George Toepher, Homer Sudduth (former city commissioner), William T. Weeks, and Charles Marks Sr.; (back row) B.W. Stephenson, L.L. Tew, C.P. Lanford, W. Frazier Frith (former mayor), "Cannonball" Robertson (former city commissioner), Bill Bellflower, Whitt Hickman, J.I. McDaniels, Grady Kilpatrick, Virgil Smuts, Jimmy Mowat, Leslie Porter (former city commissioner), W.A. Jones, J.R. "Jimmy" Floyd, J. Trawick, Bobby Easom, Reverend Cole, Harry Jackson (former mayor), Ted Jacobs, C.D. Youngblood, Reverend Meikle, George Cooley, Fred Peach, Ed Hoffman, John A. Wright, and Robert C. Vanhorn. (KF.)

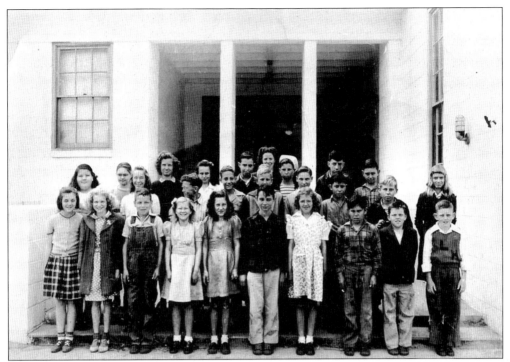

This was one of the last groups to attend classes in the wooden school building. The school burned the night before the beginning of summer break in 1944. The last little boy on the end of the front row is Talley Bludworth. (TB.)

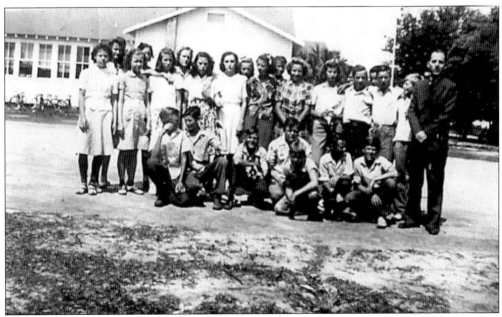

In 1943, this class of Lynn Haven eighth-grade students completed their education in their hometown. To attend Bay High School, they would gather at the corner of Ninth Street and Florida and meet the school bus that would take them into Panama City. (RFC.)

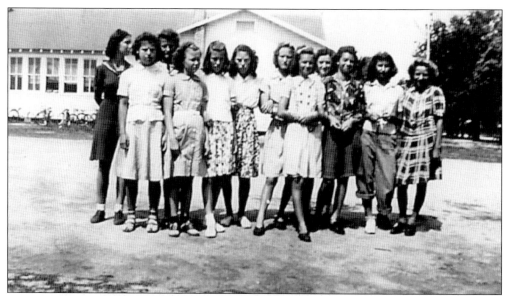

This 1944 class at Lynn Haven Elementary School is enjoying the last days of school. Mary Roberts received not only a certificate of completion but an award for perfect attendance throughout her school career. (RFC.)

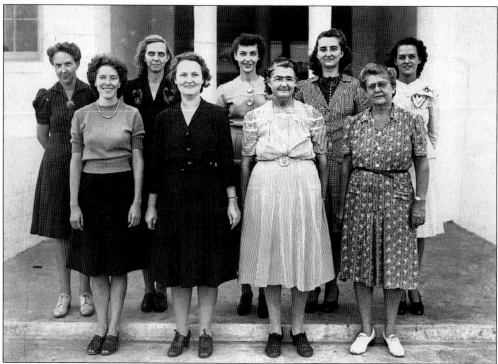

Pictured are members of the 1946 Lynn Haven Elementary School faculty posing at the entrance to the new school. This building replaced the wooden structure that burned in 1943. Shown here from left to right are (front row) Mrs. Cayton, Gertrude Bludworth (principal at the time), Mrs. Davis, and Mrs. Bessie Dauphin; (back row) Mrs. Violet Hayward, Mrs. Williams, Mrs. Manious, and two unidentified teachers. (BCPL.)

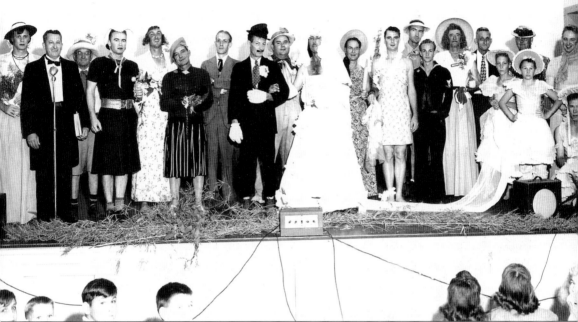

This "womanless wedding" was performed for a community night at the Lynn Haven School in the late 1940s. Pictured, from left to right, are Arnold Stancil, Hubert Brannon, ? Robinson, Luther Land, Lloyd Proctor, Harris McCormick, Ralph Gibson, Ed Hoffman (groom), Russell Hobbs, Harold Geho (bride), unidentified, Cluster Cartwright, Marvin Mashburn, Don Garrett, Perry Kyser, Eddie Hoffmann, ? Griffith, Mike Brannon, George Cooley, and Jim Mowat. (KF.)

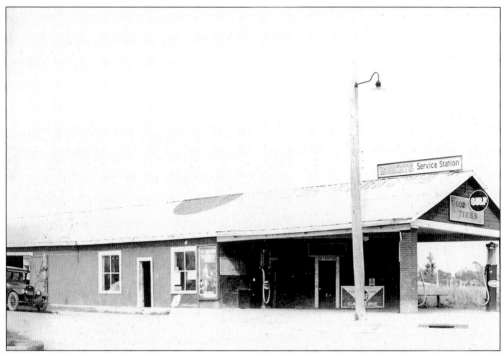

The Gulf service station and tire store operated by L.C. Roberts was located on Ohio Avenue across the street from City Hall. (RFC.)

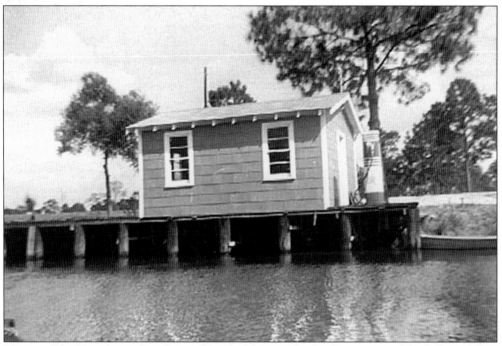

This small building located at the south end of the wooden bridge spanning North Bay is often referred to as the Lynn Haven Marina. Note the pump at the dock where boaters could purchase fuel. (BCPL.)

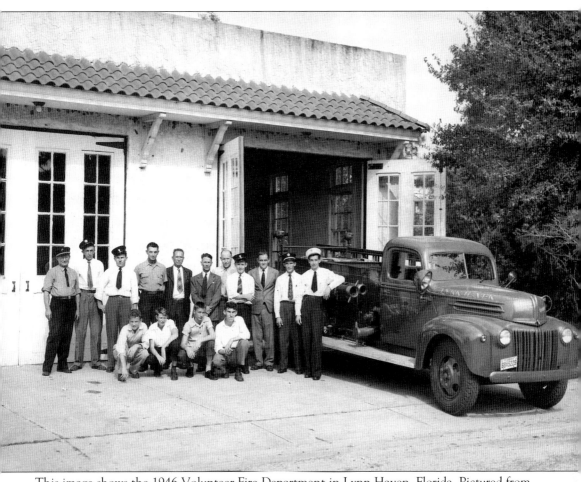

This image shows the 1946 Volunteer Fire Department in Lynn Haven, Florida. Pictured from left to right are (front row) Billy Kinsaul, Red Stancil, Ray Proctor, and J.G. Mercer; (back row) Teck Rocher, Fred Peach, David Rocher, Bill Ridgeway, Harry Jackson, Alfred Kinsaul, Jack Cook, Martin Rocher, Ray Jacobs, Charles Van Horn, and John Wright. (KF.)

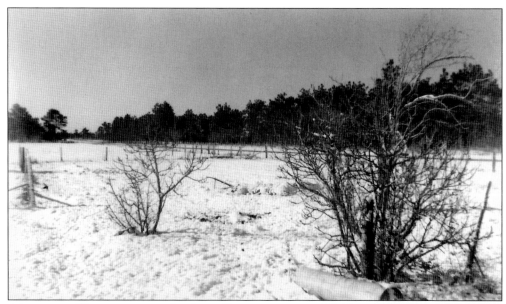

About every 30 years, it seems that Lynn Haven sees a snowfall. Here, a blanket of snow covers the Mowat Dairy pastures in 1958. (MFC.)

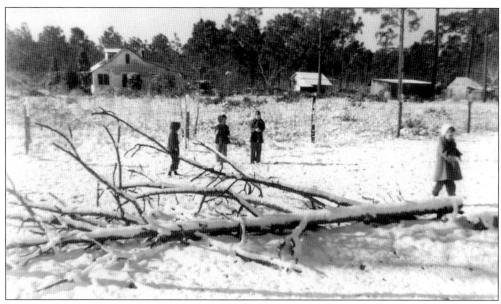

Enjoying a rare experience, this group of third-generation Mowat children are playing in the snowy fields. (MFC.)

Seven

SEMI-CENTENNIAL

"Lynn Haven, A Good Place to Call Home"

The little colony met the big 50 with a big birthday party. Lynn Haven's looks really began to change. The city's school for black children, March Green Elementary, was closed, and Lynn Haven Elementary was integrated. A new high school, a new library, and new businesses were opened. Traffic sped through town on a four-lane Ohio Avenue, and the business district, once on Florida Avenue, spread along the highway. Steady building increased the residential population.

The little town that had been promoted as the "Magic City," "the Rose City," and "Satsuma Land" did not seem to need advertising and clever names. Just like an earlier sign on the edge of town stated, it was a good place to call home.

SCHEDULE

8:30 AM - ADDRESS OF WELCOME by Mayor Harvey Liddon followed by a memorial service.

9:00 AM - JUDGING OF COSTUMES

9:30 AM - BASEBALL GAME

10:00 AM - PARADE

10:30 AM - CROWNING OF BEAUTY QUEEN

11:30 - 2:30 PM - FISH FRY

11:45 AM - FLAG CEREMONY at Veteran's Monument

1:15 PM - PRESENTATIONS AND RECOGNITION

1:30 PM - ADDRESSES

2:00 PM - SKI SHOW with BOAT EXHIBIT on park grounds

5:00 - 7:00 PM - MUSICAL ENTERTAINMENT

8:00 - 11:00 PM - STREET SQUARE DANCE EVENTS

The Garden Club on Ohio Avenue will serve as reception center and will be open from 8:00 AM thruout the day. Visitors are invited to sign the registration book and enjoy the center for social relaxation at any time during the day. Games and recreation equipment will be set up at the Garden Club building from 8:30 to 10:00 AM.

This is the program of events that took place in honor of Lynn Haven's Semi–Centennial. The celebration was an all-day affair beginning with a memorial service, highlighted by a flag ceremony at the monument and a fish fry. The events concluded with music and a street dance. Dr. James Martin was general chairman of the events, and he extended a welcome to visitors and invited them to tour the town to see its growth of the past 50 years. Mayor Harvey Liddon considered it a total success due to the cooperation between the city and its citizens. (AC.)

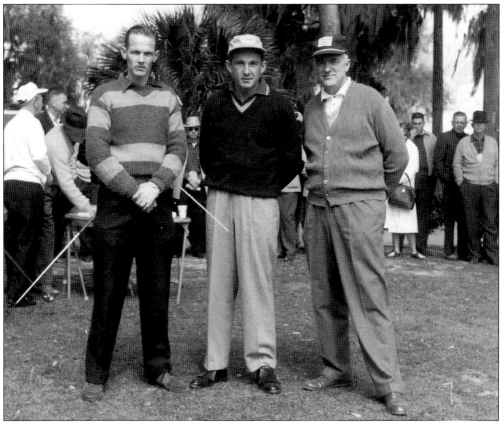

Enjoying a day on the links in the Little Tournament of Champions at Panama County Club in 1963 are, from left to right, Billy Kinsaul, Dow Finsterwald, and Sam Fleming. The tournament was an annual pro-am event for a number of years. Many well-known professionals came to play in the event. (KF.)

This Panama Country Club Clubhouse served members from 1961 to 1994. It was located in almost the same position as the Gay home 50 years earlier with its expansive view of North Bay and the opposite shoreline.

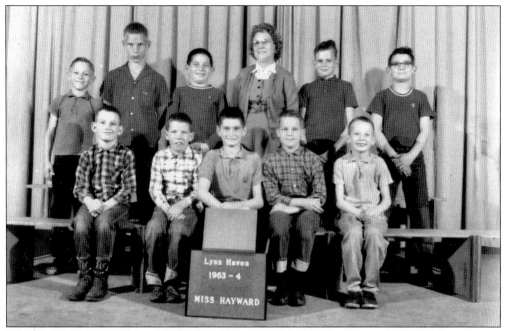

Miss Violet Hayward has a class of all boys at Lynn Haven Elementary in 1963. This group is not the sweet demure group pictured in the last chapter. She taught school for nearly 40 years, and many students recall her as their favorite teacher. (SK.)

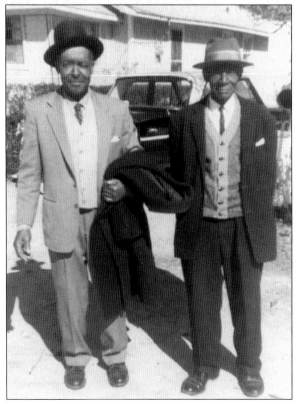

March Green and Charlie Parker take a walk and visit friends after church. Green came to Florida in 1904 to work in the naval stores industry, but he also became a businessman. He helped build Tyndall Field and owned a business in East End. When Lynn Haven Elementary School for black children was built, he ran electricity from his house to it. March Green School, the last one built for blacks before integration, was named in his honor. (GG.)

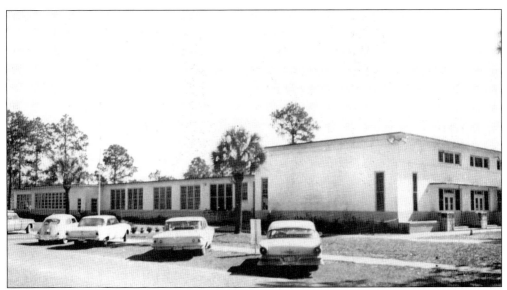

Pictured here as it looked in the 1960s, before the days of portable classrooms and chain-link fences, is Lynn Haven Elementary. In those days, many children walked or rode bikes to school and looked forward to a stop on the way home at Lloyd's Country Store, where sodas were fished from an icebox and penny candy was a penny. (SK.)

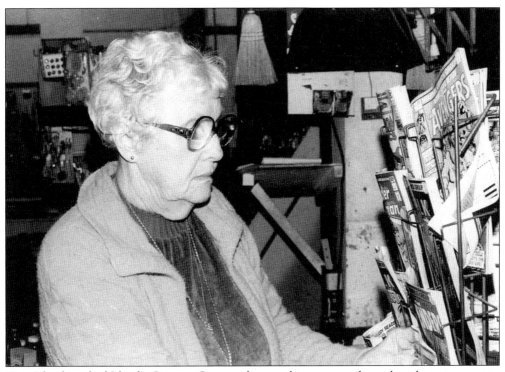

Kitty Lloyd stocked Lloyd's Country Store with everything you might and might not expect to find. Kids were always welcome and knew there would be the latest comics, candy, and cold drinks waiting for them. Of course, there was the greeting and plenty of chatter from Miss Kitty or Papa Lloyd that made it a special place to visit on the way to or from school. (LHPL.)

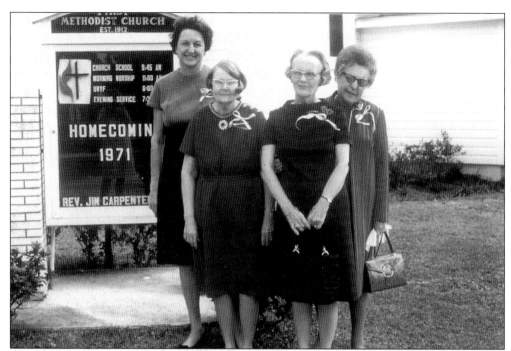

These ladies are attending the Methodist homecoming in October 1971. Pictured from left to right are Marian Rose Pippin, Gladys Zion Porter, Wanda H. Kinsaul Hurst, and Geraldine S. Fick. (LHUMC.)

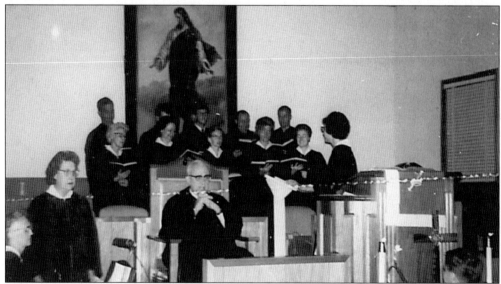

The Methodist choir is singing during a Sunday morning service in the original building. Seated at the organ is Mae Marks, and Nettie Sanders stands beside her. The minister, seated at center, is Marvin Heaton. Note the painting hanging in the background. This larger-than-life-size painting of the ascending Christ was made for the church by William Rose and installed in February 1917. It remained on the wall behind the communion table until the building was demolished in the 1970s. Although not signed by the artist, it is known as the Rose painting. (LHUMC.)

William A. Hearn served the congregation of the First Presbyterian Church and the Lynn Haven community during the 1970s. He was one of the most beloved ministers in Bay County. His wife, Elizabeth, can be seen in the background. (LS.)

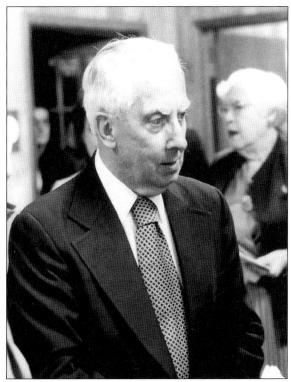

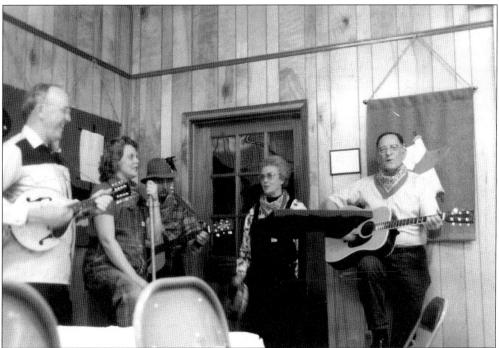

Presbyterian Fellowship Suppers on Sunday night meant good food and fellowship for all. Here, some talented musicians perform. Pictured from left to right are Harold Rains, Ronda Holley, Ronnie Mathis, Amy Musgrove, and Vaston Mathis. (LS.)

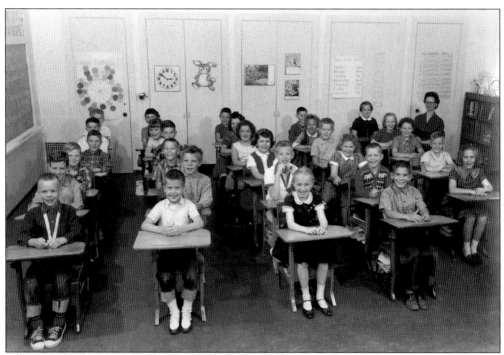

This elementary class was taught by Mrs. Mary Sharp at Lynn Haven Elementary School in 1961–1962. (SK.)

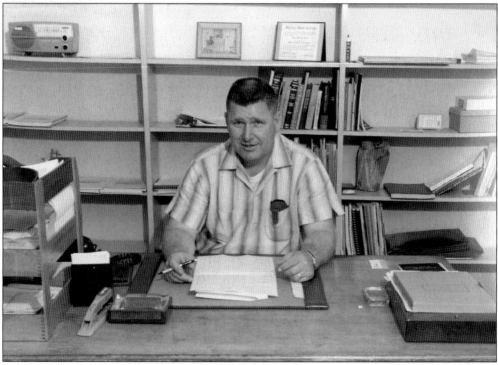

Tom Nield became principal of Lynn Haven Elementary School in the late 1950s and retired in 1985. (SK.)

When A. Crawford Mosley opened, Lynn Haven high school students no longer had to travel into Panama City to attend Bay High School. Marvin McCain was the first principal. The school was considered quite a modern educational facility at the time. It occupied 4.5 square acres and had its own swimming pool. (MM.)

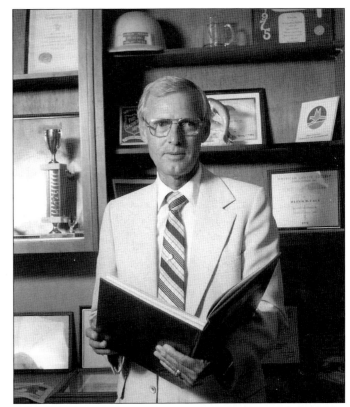

Principal Marvin McCain was named to that position while plans for the school were still on the drawing board. He awarded thousands of diplomas to graduates during his tenure. He retired in 1982. (MM.)

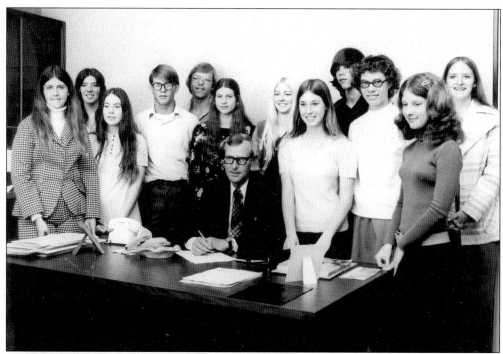

Mr. McCain is shown surrounded by students as he signs the charter to establish the first Beta Club at Mosley High School. Nearly 2,000 students were enrolled at Mosley when its doors opened. (MM.)

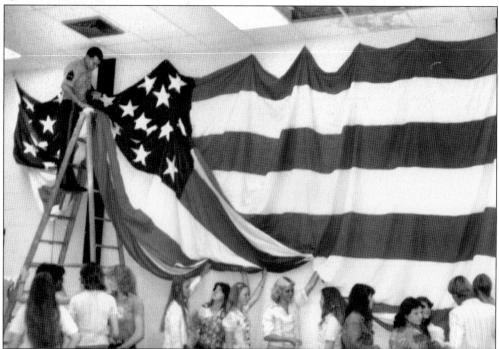

Mosley High students decorate the walls of the school cafeteria for their bicentennial celebration. (MM.)

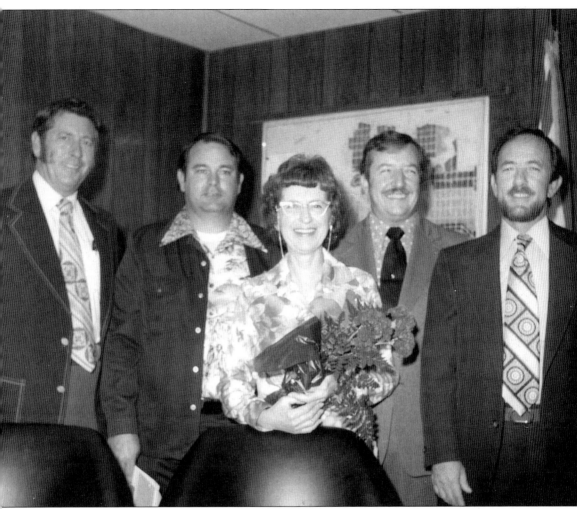

Smiles abound as four city commissioners and a new mayor are sworn into office. Commissioners are, from left to right, George Hall, Randy Holley, Rick Kummer, and Jim Rodgers. In the center is Lynn's Haven's first female mayor, Montel Johnson. The date is February 4, 1976. Mrs. Johnson had served several terms as a commissioner before she ran for the mayor's seat. She was the first female to hold that position in the city and the county. She served as mayor from 1976 to 1986, but she came out of retirement for another term in 1995. (MJ.)

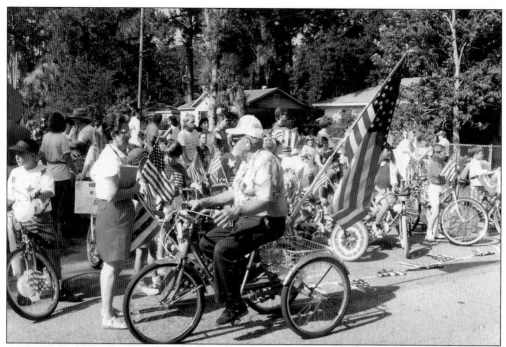

Bicycles and Fourth of July parades just go together in Lynn Haven. Here, Frank Schilling (center), owner of the Bicycle Shop, organizes participants and talks with Norma Todd. (LHPL.)

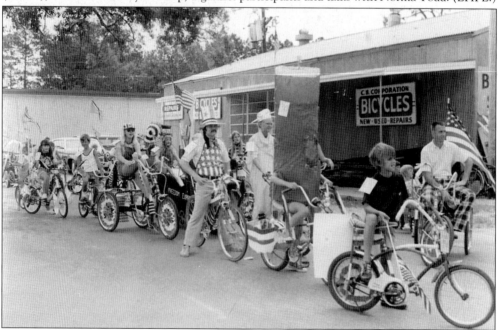

Highly decorated bikes are lined up to join the Fourth of July parade. The competition for prizes in the parade's bicycle division is a serious matter to the participants. There are categories for adults and children of all ages, but most would find it hard to say whether the competition is more fun than the decorating. In this photograph, Dick Adams can be identified at far right on a large tricycle. (LHPL.)

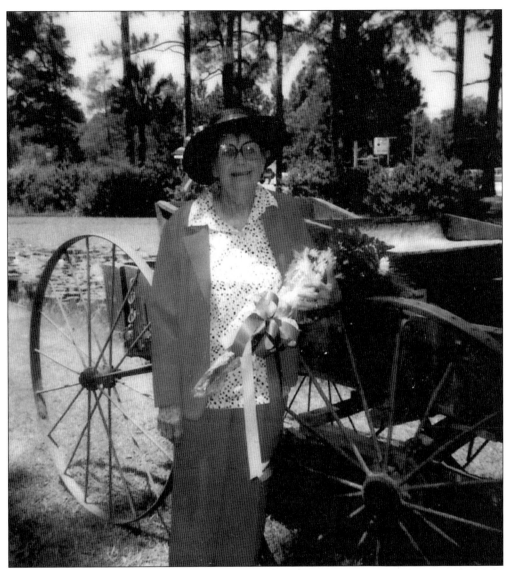

Here Catherine Middlebrooks Lloyd, better known as Miss Kitty, the proprietor of Lloyd's Country Store and friend to all, is honored as grand marshal of a July 4th parade. Dressed in an outfit of red, white, and blue, she rode the parade route in a horse-drawn wagon. (SH.)

The Lynn Haven Garden Club entered this float in the Bicentennial Fourth of July parade. It depicted a garden scene complete with Southern belles. Club members, with help from their families, built and decorated the float. As their community project for the bicentennial year, the club members took responsibility for the care of the Union Monument. The soldier was removed from his pedestal and refurbished. The surrounding base was painted and landscaped. Once the project was completed, the women worked hard to maintain the grounds and convert them into an inviting park. (SH.)

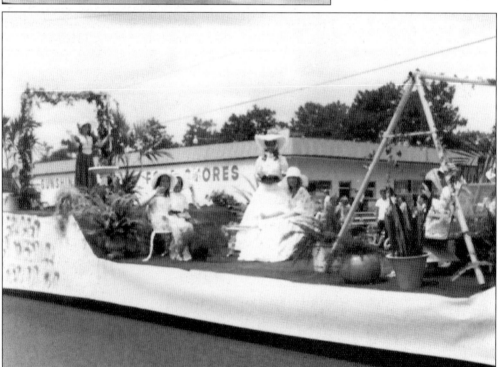

Another view shows the garden club float traveling down Ohio Avenue. The costumed girls riding the float were all daughters of club members. From left to right are Sherry Meyer, Margaret Walters, Cheryl Hutton, Sarah Hutton, Michelle Cotton, and Patricia Cotton. (SH.)

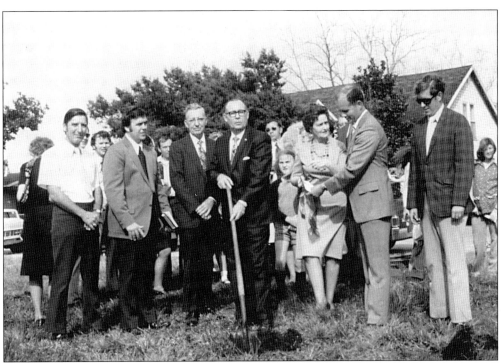

Quite a crowd participated in the groundbreaking for a new Methodist sanctuary in the 1970s. Shown in the forefront, from left to right, are Al Tunnell, Rev. Jim Carpenter, two unidentified Methodist District Officials, Winnie Blue, Roger Johnson, and Larry Villars. (LHUMC.)

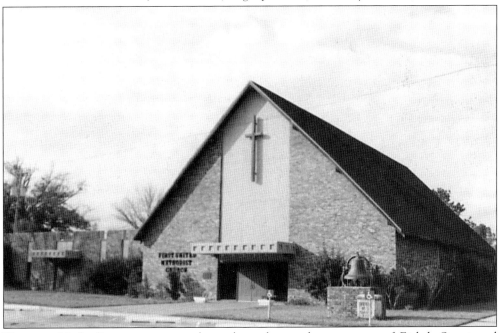

The new Methodist sanctuary was located on the northwest corner of Eighth Street and Pennsylvania Avenue, diagonally across from their original structure, which was demolished. The bell and cornerstone from the first building are displayed out front. (LHUMC.)

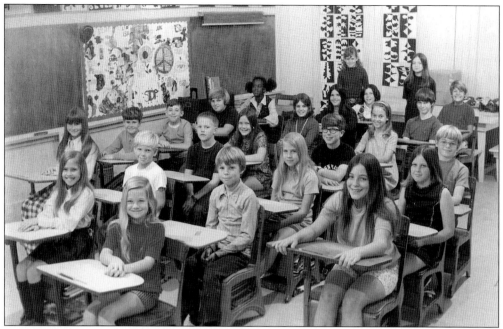

Mrs. Shirley Kilpatrick was the teacher of this combined fourth- and fifth-grade class at Lynn Haven Elementary School in the 1970s. Some of the class members are Lisa Walters, Allen McCain, Michelle Cotton, Terry Todd, and Lena Deal. (SK.)

Baseball has been a favorite pastime in Lynn Haven since the first team was organized in 1911. Here, members of the Hurst Adams–sponsored T-ball team take a break from practice. The boys are, from left to right, Brian Timmons, Shaun Gautier, and Lee Walters. (AC.)

Gladys Porter began playing the organ at the Methodist church as a very young girl. She could recall playing evening services with only oil lamps to illuminate her music. She was married to Leslie Porter, who operated a sawmill in the early days of settlement. The waterfront park on the west side of Bailey Bridge, Porter Park, was named in honor of her husband and his civic contributions. (LHPL.)

Mrs. Mary Ella Roberts, daughter-in-law of settler L.J. Roberts, celebrated her 88th birthday in 1990. It was tradition for the Roberts clan to gather for dinner every Sunday after church at her home on Florida Avenue. Homecoming was a weekly event for that family. (LHPL.)

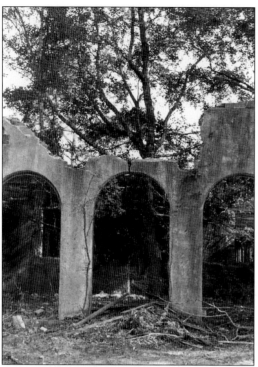

Ruins of Bob Jones College were overgrown and tumbling down until the 1990s. The neglected property was a "haunted place" according to the young people who challenged others to go there at night. A number of ghost stories were made up and told of imaginary events that happened to the students who once lived there. Bob Jones University is now located in Greenville, South Carolina. (LS.)

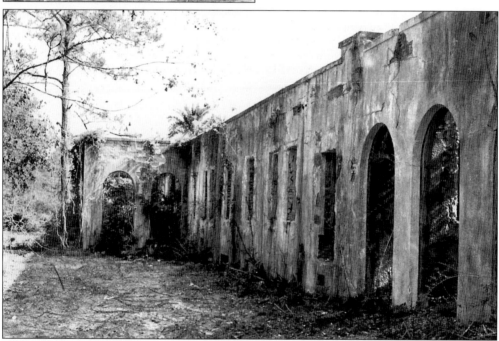

The outline of the arched windows draped in vines testifies to the elegant administration building of the college. There was a dormitory for women, another for men, the administration building, and classrooms. Members of the faculty also had homes on the surrounding property. Lots were sold to the public with the promise that part of the price would help support the college. (LS.)

Eight

LOOKING TO THE FUTURE

The very fact that we have survived the vicissitudes, the setbacks, and disappointments, and handicaps that have come our way is evidence of the sterling quality of our pioneers and it proves that it is not the skyscrapers, the modern improvements that appeal most to the inner lives of people but the association of those who are in sympathy with our abilities and purposes.

—Cora Bailey, 1929

A new century has begun and Lynn Haven is nearing its centennial. The settlement has become a boom town once again as the frantic rush for coastal property continues. Many things have changed just as all things do when they age, but some of the past can still be found. There is a hometown feeling not usually found in the suburbs, and three of the original churches are still cornerstones in the community. The park still hosts concerts, while the Fourth of July celebration is still the biggest and best in the county. Of course, above all is still a town filled with the "most interesting people you would ever want to meet."

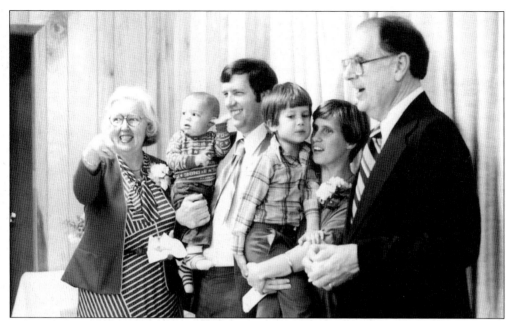

In 1981, Rev. James N. Montgomery and his family arrived to serve the congregation of Lynn Haven Presbyterian. Taken at his welcoming reception, this photograph shows, from left to right, Montgomery's mother, Reverend Montgomery holding son Nathan, wife, Elysa, holding son Timothy, and Montgomery's father. By the time the family relocated 11 years later, little Mary Margaret had joined the family. (LS.)

This is the Sunday school class taught by Miss Margaret Walters as they pose before the doors of the First Presbyterian sanctuary on a spring morning in 1984. Members of the class, from left to right, are Autumn Miller, Nathan Montgomery, Stephanie Hearn, Buddy Stebbins, April Holley, Samantha Snyder, unidentified, and Catherine Hearn. Walters, their teacher, was baptized in the church in 1973 and was married there in 1988. (AC.)

The ribbon to open the Sarah Hutton Bridge in the city park on July 3, 1982, was cut by Mayor Montel Johnson. Pictured from left to right are Henry Suggs, James Powell, Mayor Johnson, Baptist pastor Don Jones, and the honoree, Sarah Hutton. It was under her leadership as president of the Lynn Haven Garden Club that restoration of the bridge and a renovation of the park was accomplished. (SH.)

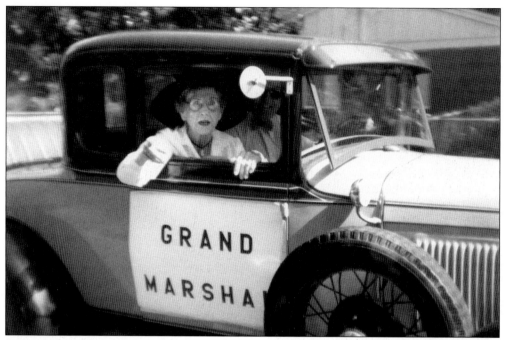

Carrie Hobbs Maxwell enjoys the Fourth of July parade in 1985 as the grand marshal. She is riding in an antique car driven by nephew Gene Hobbs. (LT.)

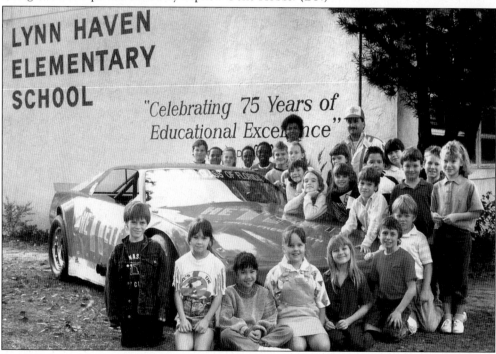

In 1988, Lynn Haven Elementary celebrated its 75th birthday. A class of boys and girls taught by Rosa Long poses in front of the sign on the school building marking that important milestone. On this particular day, the class is honoring completion of an anti-drug campaign sponsored by an oil company. (SK.)

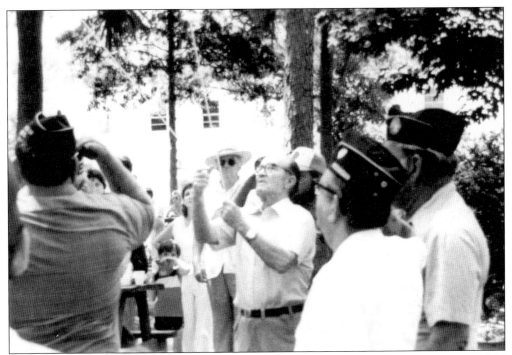

Luther Land was a small boy watching the Lynn Haven Park's dedication in 1935. He was asked to step forward and raise the flag that day. On the 50th anniversary of that event, he was again asked to raise the colors. (LHPL.)

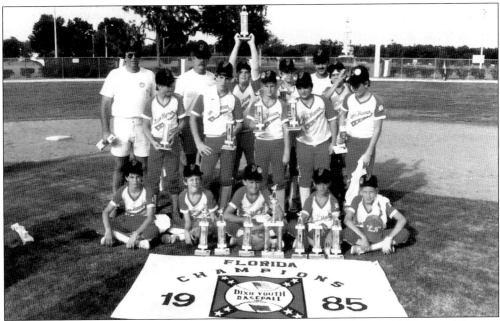

In 1985, this team of young Lynn Haven men continued the tradition of a successful sports program in their hometown. These all-stars represented the city in the state tournament of the Dixie Youth Baseball League. They returned home with the title of Florida champions. The team went on to compete in the Dixie World Series in South Carolina. (AC.)

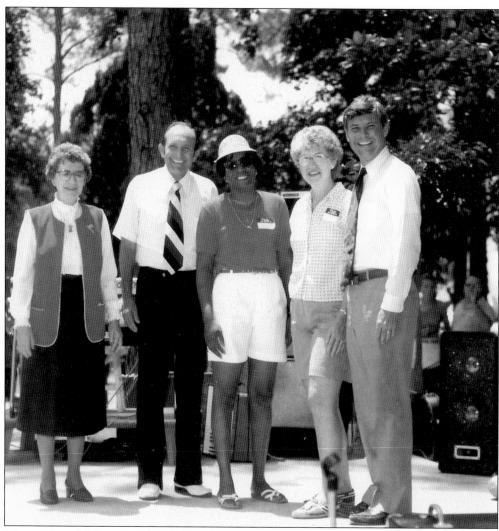

Mayor Montel Johnson welcomed Gov. Bob Graham and Congressman Earl Hutto to Lynn Haven's Fourth of July celebration as they made a campaign swing through North Florida in 1986. Pictured from left to right are Mayor Johnson, Congressman Hutto, Commissioner Sheffield, Sarah Hutton, and Governor Graham. (LHGC.)

Gov. Bob Graham addresses the crowd from a stage in the park. (LHGC.)

Congressman Earl Hutto also spoke to his constituents enjoying a typical Lynn Haven Fourth of July. (LHGC.)

Sharon Sheffield won over 1,000 votes in Lynn Haven's 1986 election to become the first black woman elected to public office in Bay County. Commissioner Sheffield can be seen here listening to a constituent. (SS.)

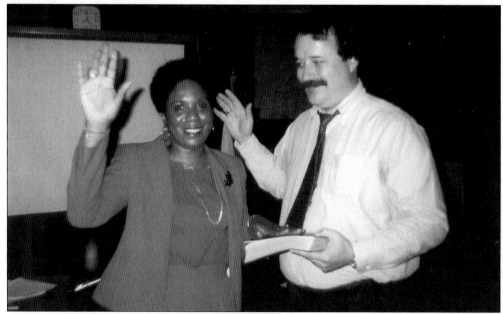

Sharon Sheffield became mayor of Lynn Haven in 1990 upon the resignation of Ron Barber. Here, Ms. Sheffield is sworn in by attorney Bill Hutto. (SS.)

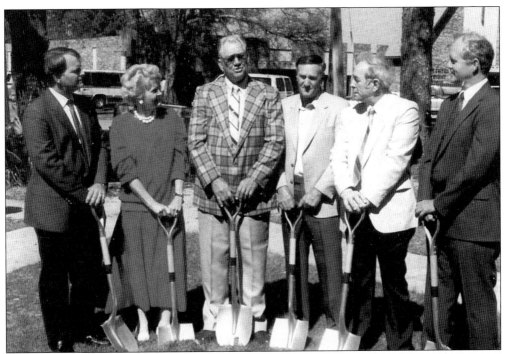

The groundbreaking for an addition to the North Bay Library was held in late 1989. Pictured here are architect Norman Gross Jr., board member Carolyn Ireland, Rep. Sam Mitchell, Bill Perry of Perry Construction, Mayor Ron Barber, and Roger Johnson. (CLH.)

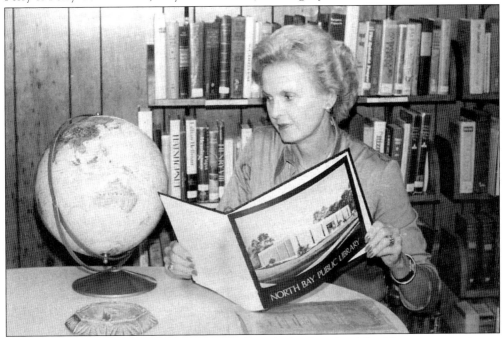

Carolyn Ireland was active in raising funds through the friends of the library organization to bring a new and modern library facility to the city in 1970. She continued her support through the years and was instrumental in securing in 1990 an addition to the building as well. (LHPL.)

Although rare, it does snow in Lynn Haven. Here, the Lynn Haven Presbyterian Church grounds are covered in white. The snow began on the evening of December 23, 1989. Big flakes came down and rapidly covered the ground. It stayed on the ground for most of three days. (AC.)

Here is a yard in the College Point area blanketed by snow. Christmas decorations began to look more traditional as Santa's sleigh and reindeer were not resting in sand. (AC.)

120

This was
the original site of
BOB JONES COLLEGE
(1927 – 1933)
now
BOB JONES UNIVERSITY
located in
Greenville, South Carolina,
The World's Most Unusual University,
non-denominational, co-educational,
Biblical, orthodox.

"...I have set before thee an open door,
and no man can shut it,
for thou hast ... kept my word,
and hast not denied my name."
Revelation 3:8

All that remains of the Bob Jones College campus is this marker. The dilapidated structures were removed and the property was platted into a subdivision named Mill Bayou. Now a number of upscale homes fill the landscape. (LS.)

This amusing squirrel is the by-product of damage inflicted by Hurricane Opal. The storm, which struck Bay County in October of 1995, destroyed many of the old trees that lined the shoreline of the Panama County Club. With the help of a talented and imaginative craftsman, this squirrel emerged from the topless base of a fallen tree. (AC.)

A new clubhouse was built in the early 1990s at the Panama Country Club, and the course was redesigned to accommodate luxurious homes along the waterfront. (AC.)

This photo was taken at the opening of the newest Bailey Bridge in the late 1990s. This modern, four-lane span replaced the 1946 bridge but remains named the Bailey Bridge. The old bridge spans are located to the east of the new structure and are used as a fishing pier. (AC.)

Now Lynn Haven has a skyline. This change came with the construction of the Marina Bay condominiums on the northern shore of North Bay, almost opposite the site of the old dock where settlers first entered Lynn Haven. With the annexation of the condominium site, the city limits crossed the Bailey Bridge, and additional construction of high-rise buildings is anticipated. (AC.)

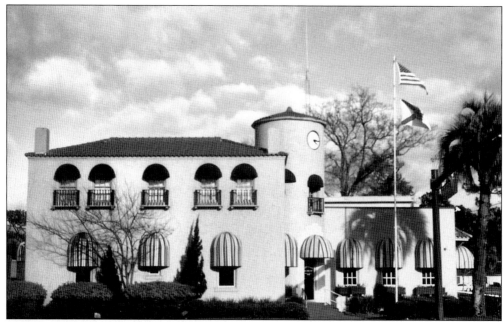

The Lynn Haven City Hall had a face lift as the century came to a close. The fresh paint, colorful window-box planters, and awnings accent the unique architectural features of the old but sturdy building. No doubt the building will continue to serve the city for many years to come. (AC.)

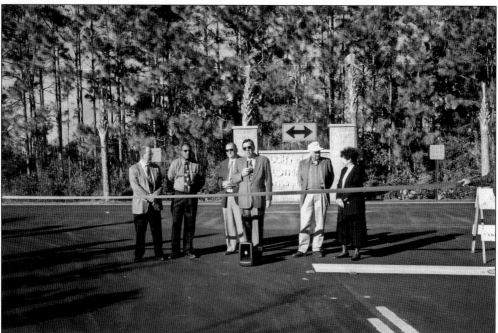

Cutting the ribbon to open a new entrance to the Lynn Haven Industrial Park are Joe Tannehill, Commissioner Francis Wittkopf, Mayor Walter Kelly, and Commissioners Harold Haynes, Antonius Barnes, and Roger Schad. The industrial park is located on the east side of town, while the commerce park is on the west side. (CLH.)

The Lynn Haven Methodist Church began its third expansion program with the purchase of property on the outskirts of town. The placement of this sign announced their plans. Shown here from left to right are Jeff Nauman, Rev. Doug Williams, and Frank Smith. (LHUMC.)

Services were first held in the new United Methodist Church building in June 2004. It is equipped with overhead screens and an advanced sound system. The new facility has allowed the church to expand its community presence in the form of education and family recreation. (LHUMC.)

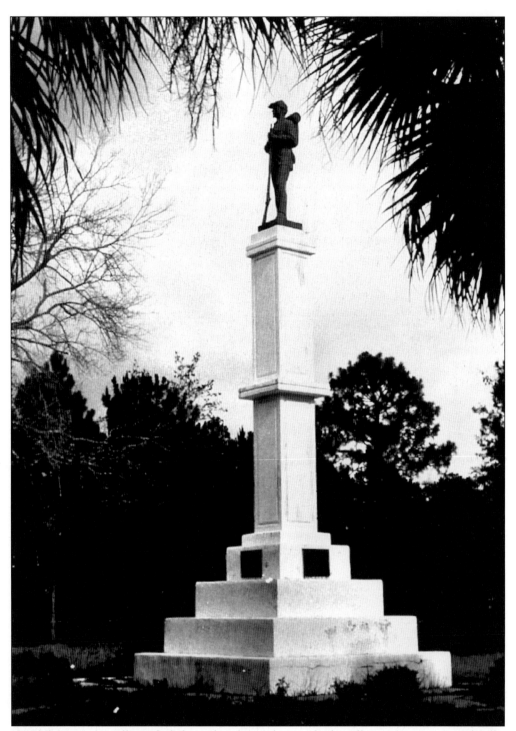

Union Monument still stands dedicated to those who perished in all wars. Its neat grounds offer benches to those who would wish to sit, but unlike those who first came, people seldom do. It could be that the present population forgets to enjoy just what the settlers sought—tranquility and sunshine. (LHPL.)

Here a Union tombstone marks the grave of a Civil War veteran. For nearly a century, James W. Duvall of Company C, 2nd Ohio Heavy Artillery, Battery G, has rested here. His arrival was noted in the first list of veterans published by the *Pilot* in December 1910. Accompanied by his wife, he came from Dayton, Ohio, to spend his remaining years among his comrades. (AC.)

Sitting alongside the GAR tombstones is one marked with the flag of the Confederacy. Here rests John McAllister, Company A, 51st North Carolina Infantry, who died in 1917. Much blood was shed for their differences, but peace came for them here. (AC.)

This planter gives little hint of the city's history. If someone passing through this little North Florida town recognized it as a pan for rendering salt from sea water, they would quickly assume that Lynn Haven was a settlement of the "Old South" whose citizens produced salt for the Confederacy. The pictures represented between these pages are intended to reveal the diverse and unique qualities in a community that features a monument in Union uniform, graves of Civil War soldiers representing both the Union and the Confederacy, and continuing patriotism. (AC.)